IMAGES
of America

PHILADELPHIA
TROLLEYS

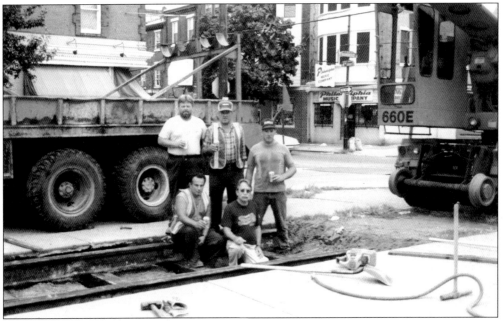

Above, we see the construction of a dream. Joel Spivak, an avid transit historian, held a trolley birthday with the help of some friends. A monument to the trolley was dedicated on the 100th anniversary of the first electric streetcar in Philadelphia that ran on Catharine and Bainbridge Streets. The Southeastern Pennsylvania Transit Authority brought out the heavy equipment to start the monument in 1993. The completion of the trolley monument included a neighborhood and citywide celebration attended by city dignitaries. Below, the Famous Delicatessen on the corner of Fourth and Bainbridge Streets appears in the background.

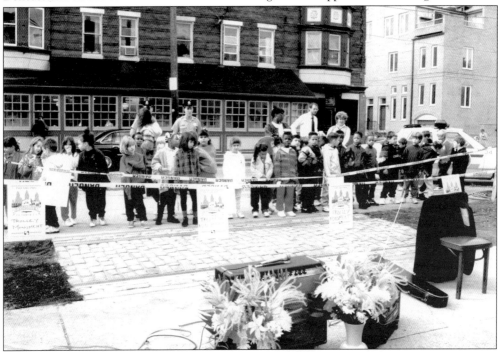

IMAGES
of America

PHILADELPHIA
TROLLEYS

Allen Meyers and Joel Spivak

ARCADIA

Published by Arcadia Publishing,
an imprint of Tempus Publishing Inc.
Portsmouth NH, Charleston SC, Chicago,
San Francisco

Printed in Great Britain

Library of Congress Catalog Card Number: 2003104550

For all general information, contact Arcadia Publishing:
Telephone 843-853-2070
Fax 843-853-0044
E-mail sales@arcadiapublishing.com
For customer service and orders:
Toll-free 1-888-313-2665

Visit us on the Internet at www.arcadiapublishing.com

On the cover: The Route No. 40 trolley car ran from South Philadelphia to Fortieth Street and Girard Avenue, where America's centennial was held. The wooden trolley cars gave way to the modern PCC (President's Conference Cars) in the cover photograph, taken at Seventeenth and Lombard Streets in South Philadelphia during May 1955. (Courtesy of Railroad Avenue Enterprises.)

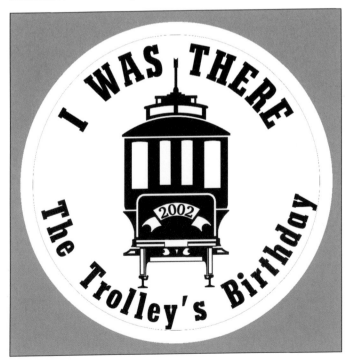

A large, round adhesive badge entitled visitors, friends, and family to join in the festivities for the trolley's birthday and to keep as a souvenir. Joel Spivak celebrates the trolley's birthday with children and adults who have enjoyed cake and refreshments annually in Philadelphia since 1993. In 2002, the celebration lasted the whole month of December and was held at the Da Vinci Art Alliance, located along the original trolley car route on Catharine Street.

CONTENTS

PREFACE

Contained in the following pages are the lifelong dreams of two Philadelphians who love the urban environment and transit history that are part of the city's very existence. Both Allen Meyers and Joel Spivak grew up during the 1940s and 1950s, the era when the trolley car provided continuous transportation to school, ballgames, relatives' homes, downtown shopping, and social events. The trolley car was revered and respected as if it were part of a person's larger family. The daily appearance of the trolley car in the lives of the authors gave them a greater sense of community, because the vehicle always carried an operator who knew where he was going and made it fun to travel.

The urban experience in the mid–20th century gave Joel Spivak, born in 1939 and raised in West Philadelphia near Forty-second Street and Girard Avenue, a real foundation for appreciating the many trolley cars that ran in the neighborhood. Spivak's early years were spent with his grandparents Morris and Hannah Spivak watching the trolleys on Fortieth Street slow down before they crossed the bridge over the Pennsylvania Railroad.

Like many families, Phil and Helen (Kramer) Spivak and their children, Robert, Lynn, and Joel, migrated to another part of the city after World War II. They relocated to the West Oak Lane section up North Broad Street to Sixty-sixth and Ogontz Avenue. The new experience with public transportation was huge. From taking the famous Route No. 55 trolley to school, to hopping the Route No. 6 to Willow Grove Amusement Park in the northern suburbs of Philadelphia, to just plain riding the Broad Street Subway into downtown via the Broad and Olney transit hub the Spivak family was allowed the cosmopolitan experience of a new neighborhood.

Born in 1953, Allen Meyers lived in the Strawberry Mansion section of North Philadelphia. Meyers enjoyed the many trips on the Route No. 9 trolley car with his parents, Esther and Leonard, and his brother Mitchell to South Philadelphia to visit grandparents and shop on Seventh Street. The family went on outings to the Phillies baseball stadium via the Route No. 54, took the Route A bus into the northeast section of Philadelphia via a transfer to the Route R bus, and rode the Route No. 61 trackless trolley bus into downtown after the Route No. 9 trolley car stopped running in the late 1950s.

Meyers's love affair with public transportation has lasted a lifetime, just like many other city residents whose families never owned an automobile.

At an early age, Meyers traveled alone daily on the Route A bus to the Whittier Elementary School after the Stockley School closed. The regular Route A bus driver allowed the little boy to sit in the driver's lap and "steer the bus" and to collect the expired transfer booklets printed in different colors to assist riders in knowing which direction they were traveling. That simple idea of associating a color with a direction has given Meyers a great sense of direction for many facets of his life; he has dreamed of becoming a PTC bus driver. Instead, Meyers knows the city very well due to that experience.

Both Spivak and Meyers have contributed to the preservation of history in Philadelphia. Spivak, an architect by profession, fathered the renaissance of South Street in the late 1970s into a revitalized destination for food and fun. Meyers, a longtime McDonald's restaurant manager, writes books about the cultural heritage of Philadelphia's neighborhoods.

You may contact Allen Meyers with your trolley stories at (856) 582-0432, write to him at 11 Ark Court, Sewell, NJ 08080, or email ameyers@net-gate.com. You may contact Joel Spivak at (215) 755-7717 or write to him at 616 Carpenter Street, Philadelphia, PA 19147.

INTRODUCTION

The development of public transportation in Philadelphia is owed in large measure to the exploitation of technology in the late 19th century, which sidelined the horse-and-wagon mode of travel. Electricity and its application to life via transportation transformed the entire city's population into a modern society. Access to various sections of Philadelphia made it possible to develop large tracts of land for residences, commerce, and recreation facilities throughout the 20th century and into the 21st century.

A timeline is necessary to explain the progressive nature of public transportation over the last two centuries. The innovation of travel by railroad in America during the 1830s led to a great increase of travel and commerce in Philadelphia. The trains, with their various functions of transporting people and goods in and out of the city, had many obstacles to hurdle. In one such instance, railroads were banned within 3.2 miles of the center of Philadelphia per a council bill for health and finance reasons.

The need to transport people from the railroad terminals, especially in the northeastern section of Philadelphia at the tip of the Kensington district, allowed the creation of the omnibus or horse-drawn passenger vehicles. The ushering of the industrial age into Philadelphia allowed forged iron to be transported into the city for rail manufacturing and entrepreneurs to create railway companies that moved people in comfort and ease. The horse-drawn railways became very popular in the Civil War era, only 10 years after the consolidation of the rural districts into Philadelphia County.

The last quarter of the 19th century proved to be very beneficial to the advancement of transportation in Philadelphia. The nation's 100th birthday celebration in 1876, held in West Philadelphia, provided many with jobs. The advent of new technology included the use of steam dummies and cable cars to transport people in the city. By the late 1880s, electricity had woven its way into the transportation industry, yet Philadelphia took another four years before it decided to allow its use, due to myths of stopping watches and hearts. In 1892, the Catharine-Bainbridge Street line was electrified, and electric storage batteries made their short-lived debut during this era. The gage of the trolley tracks were set at five feet four inches with paving, verses railroad tracks of four feet eight inches. The decision allowed street traffic such as horses and wagons to maneuver with streetcars and ride the rails themselves when bad weather flooded many thoroughfares in the city.

During the early 1900s, consolidation of the many private transportation companies into one company known as Philadelphia Rapid Transit (PRT) allowed regular fares, scheduling of service, and the sale of common stock to finance a growing company to meet the needs of the rapidly expanding urban landscape. Philadelphia built itself on the premise that it was "the workshop of the world and manufactured everything." The extra profits went into the long-range planning of the Market Street Elevated Railroad to West Philadelphia from the downtown district. The many trolley car routes were given an upgrade to feeder lines that made it all an integrated transportation system.

Grade crossings and congestion clogged the city streets and demanded an immediate solution. The Market Street Subway from west of city hall east to the Delaware River alleviated street tie-ups but did not prevent the gridlock of trolley cars and horse-drawn vehicles blocking intersections. Subway-surface trolleys underground arriving in the downtown area from West Philadelphia terminated just past city hall and helped the situation.

The urban fleet of Philadelphia-manufactured trolley cars grew to 4,000 by 1911 and served on 86 regular routes with thousands of employees. The trolley tracks, sprawling more than 649 miles, meant that a maintenance force had to continuously build and repair lines. New nearside cars replaced many open cars, and a fresh era of comfort took hold.

The arrival of World War I halted the visions of the transportation system. Scrap metal and steel were in short supply, and new elevated lines throughout the city were never built. However, the proposed Frankford extension of the Market Street El and the Broad Street Subway opened during the 1920s with great success.

The technological advancement of the automobile altered the course of trolley-car development in the post–World War I era. Buses powered by diesel entered the city in 1923 and competed for passengers on the streets with less overhead costs. By the late 1930s, the transportation industry had fought back with the introduction of the PCC streamlined trolley cars, a national design based on aircraft technology that made them more appealing to ride than the previous wooden nearside cars. Interurban travel by trolleys picked up as America entered World War II, and the trolley car resumed its role as the choice for transportation.

The reorganization of the transit system began another phase in 1938 with the creation of the Philadelphia Transportation Company (PTC). After World War II, trolleys were discontinued in record numbers due to the ease in gasoline restrictions for buses. Some electric buses did make their debut in Philadelphia for high-speed connections during this era, although the self-powered modern buses won out.

A new era evolved in the post–World War II period with the migration of the city's population into the outer ring of Philadelphia, which had huge tracts of farmland. Thousands of homes were built around the city, and the emergence of the National City Lines in the 1950s catered to this phenomenon of suburban sprawl. Firestone Tires, General Motors, and Standard Oil created the National City Lines and went around the country buying up to 51 percent of transportation companies' stock. They forced their policy of ultimately eliminating the trolley car in favor of buses.

Philadelphia underwent a third change in its transportation management in the 20th century during 1968 with the creation of the Southeastern Pennsylvania Transportation Authority, better known as SEPTA, to incorporate and coordinate urban and suburban lines for more efficient use. Air conditioned buses came on line, and the shrinkage of trolley car lines became more pronounced. City planners fought back, gaining seats on the board of SEPTA, and suggested the upgrade of the system in the early 1980s. New trackless trolleys, lightweight rail vehicles (trolley cars), and the Broad Street Subway car were ordered and put into service. The 40- and 50-year plans to upgrade equipment and physical plants culminated with the opening of new Market-Frankford El cars and the federally funded Frankford Transportation Center in 2003.

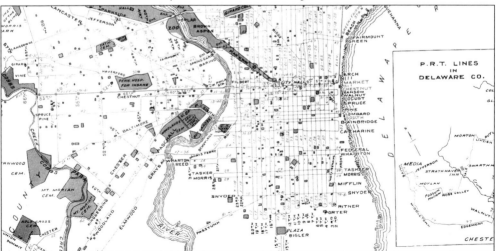

The Philadelphia Rapid Transit Company produced a trolley route map for its riders in 1924. At one time, the residents of Philadelphia could visit every section of the city via 86 trolley car routes and then make the transfers to their destinations with less than several blocks to walk.

One
EARLY HISTORY

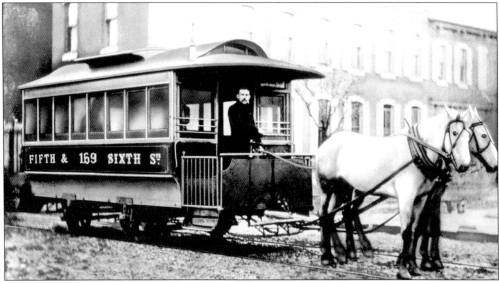

Beginning with the consolidation of the many districts surrounding Philadelphia proper in 1854, the desire to create a unified city with a diverse transportation system took shape. The railroads were limited access into Philadelphia within a three-mile radius due to smoke and noise restrictions. The first transit companies provided transportation on a street railway vehicle pulled by several horses up and down Fifth and Sixth Streets to the Southwark district in the southern section of Philadelphia, commencing operation in 1858. Those in the northeastern section of city, especially in the Kensington district, were thus given access to other areas. The line later adopted the name of the Frankford-Southwark Passenger Railway and consisted of 105 cars, 8 car houses, 4 depots, and 825 horses and collected 15 million fares in 1890. (Courtesy of Dennis Szabo.)

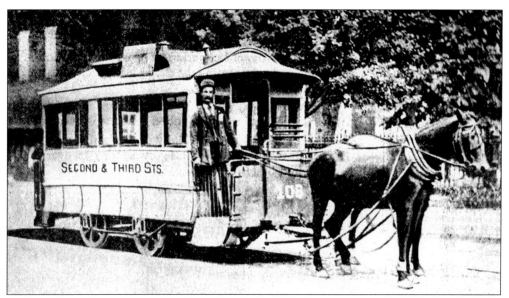

The horsecar railways operated a profitable business in the 1850s. The Second & Third Street line, shown here in 1853, ran from Second and Jefferson Streets in North Philadelphia to Third and Mifflin Streets to where the Southwark district ended. The line employed many people and included 9 car houses, 700 horses, and 109 cars valued at $800 each, with 11 million fares collected in 1892. (Courtesy of Malcolm Kates.)

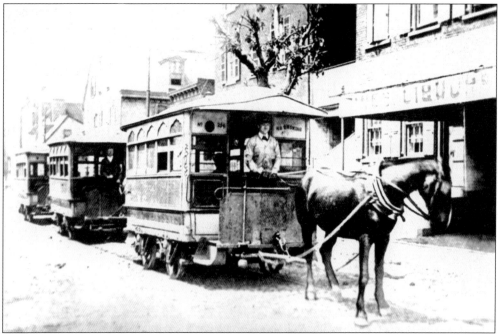

The expansion of the city provided economic growth in many sectors of Philadelphia during the 1850s. The street railway system began to replace the omnibus operations of a stage coach large enough to carry eight passengers drawn by a single horse. Created in 1857, the West Philadelphia Passenger Railway, with its many cars and track work, had replaced the mode of transportation into the downtown district by the Civil War. (Photograph by Randolph Kulp.)

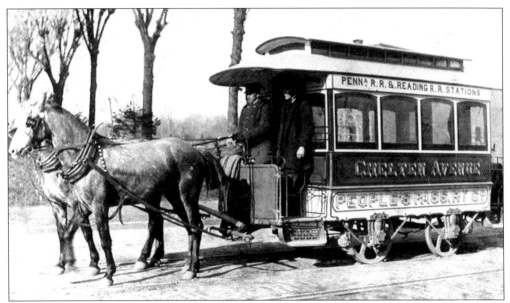

Access to the Germantown section of Philadelphia in the northwest sector of the city via railroad and then a transfer to the People's Passenger Railway took place in the late 1880s. The route was on Chelten Avenue to Rittenhouse Street. Eventually, the line encompassed 32 miles of track, 140 first-class cars, 64 second-class cars, 12 car houses, and 5 depots with many horses and carried 33 million riders in 1892. (Courtesy of the Chestnut Hill Historical Society.)

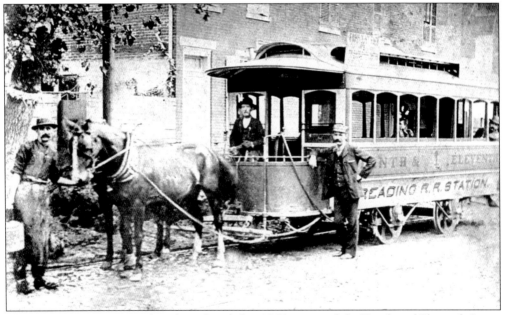

The Citizen's Passenger Railway line, founded in 1858, operated the Tenth and Eleventh Street line from Colona Street, just north of Susquehanna Avenue down to Twelfth and Mifflin Streets in the Southwark district. Easy access from the North Philadelphia Reading Railroad Station made this a popular line. This 1882 photograph includes, from left to right, waterman J. Marr, driver J. Britton, conductor B. Vogel, and passenger J.B. Sheehan, who was a city employee. (Courtesy of Dennis Szabo.)

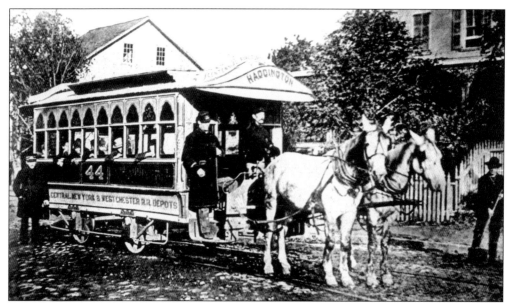

Railroad connections fed into the West Philadelphia Street Railway System following the end of the Civil War. West Philadelphia became a city within a city, and the centennial celebration in 1876 commemorated America's birthday. The Haddington Railway line was founded in 1875 and used larger cars with 10 windows that seated two dozen riders for the trip from downtown out to the centennial grounds at Forty-fourth Street and Elm (now Parkside) Avenue. (Courtesy of Dennis Szabo.)

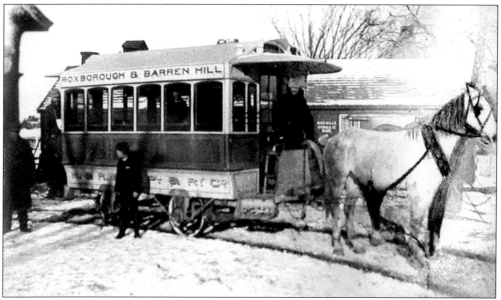

Some areas of Philadelphia were difficult to traverse. The Roxborough neighborhood along the Schuylkill River in the northwest section of the city had many hills leading up to its scenic area high above the low-lying Manayunk section. The line that serviced the neighborhood was operated in the 1880s by the Roxborough, Chestnut Hill, and Norristown Company as Philadelphia's first suburban line. (Courtesy of the Chestnut Hill Historical Society.)

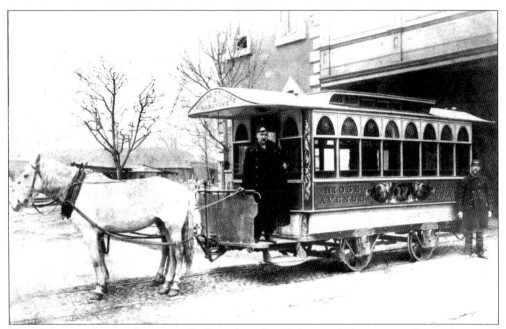

The Ridgeway Avenue Passenger Railway line from Manayunk (at present Green Lane and Main Street) traveled through Strawberry Mansion over 15 miles of double track to Second and Arch Streets in downtown Philadelphia. In 1891, the line carried seven million riders in 62 cars by more than 380 horses and mules. The harnesses and feed per animal amounted to $65. Founded in 1859, the line ended at Ridge Avenue and Columbia until 1872, when it was expanded to Manayunk. (Courtesy of Dennis Szabo.)

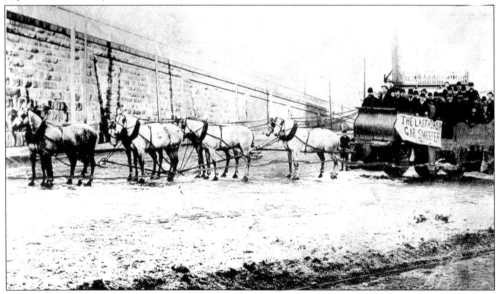

The transportation lines were granted charters by the City of Philadelphia for operation in the city with conditions and responsibilities. The passenger railways had to provide services in all neighborhoods to remove snow and horse droppings along their routes. The last sweeper for this detail duty, with its team of six horses and two mules, is captured in front of Girard College along Girard Avenue in 1896. (Courtesy of Joe Boscia.)

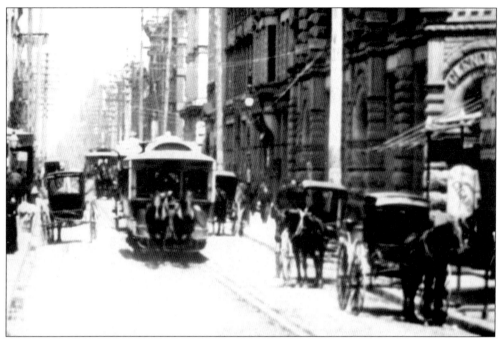

The urban street scenes in many downtown areas of the country looked alike in the era of the horse-drawn street railway. During the 1880s, many immigrants came to Philadelphia from Europe to find a homogenous city life with horse-drawn carriages and the urban street railway. In this photograph, Third and Chestnut Streets are congested with many horse-drawn vehicles. (Courtesy of Dennis Szabo.)

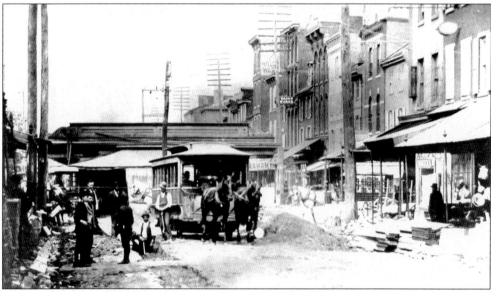

Commerce and trade benefited from this quaint era of horses and carriages. The Second & Third Street line connected South Philadelphia with North Philadelphia. The city's layout, planned by founder William Penn in 1682 in grid fashion, lent to its development. This 1880s view is looking north along Second Street at the Fairmount Avenue farmer's market. (Courtesy of Malcolm Kates.)

14

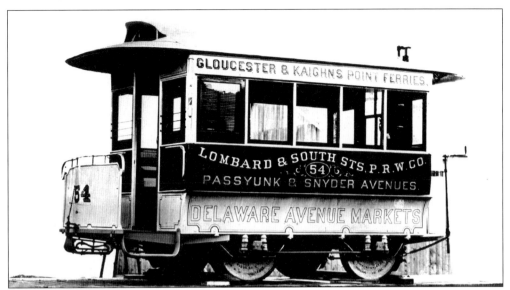

South Philadelphia had many street railway lines. The Lombard and South Street Passenger Railway operated with 47 cars, 2 sweepers, 5 car houses, and 437 horses and carried 7 million passengers in 1891. Another advantage of the city charter gave a company the right to operate in the same area in order to benefit the community. The Snyder and Passyunk line went to the foot of Delaware Avenue to connect with the ferries. (Courtesy of Joel Spivak.)

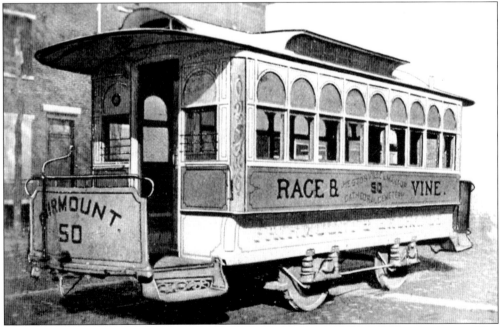

Horsecar vehicles were often displayed in trade magazines for other prospective buyers. The beauty of this car is its Bombay roof detail. The Race and Vine line, owned by the Hestonville, Mantua and Fairmount Passenger Railroad and founded in 1865, ran from Forty-first and Lancaster in West Philadelphia to Second and the Dock Street farmer's market. The usual inventory included 14 open cars and 5 box cars, used for freight only. (Courtesy of the John Gibbs Smith Collection at the Free Library of Philadelphia.)

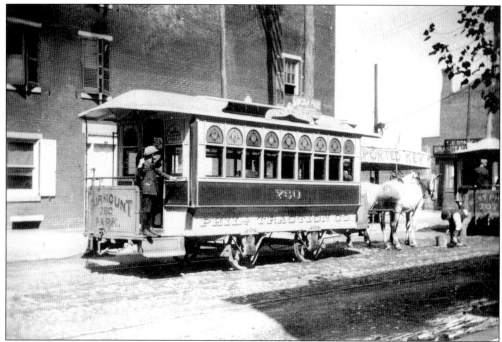

The era extended itself with the design of these horse-drawn cars in the 1890s according to Victorian details. The Philadelphia Traction Company invested in artwork for its vehicles. Stained-glass windows filtered out unwanted sunlight for the comfort of its riders. No Smoking signs were also posted in the entrance of this car in 1893. (Courtesy of Andy Maginnis.)

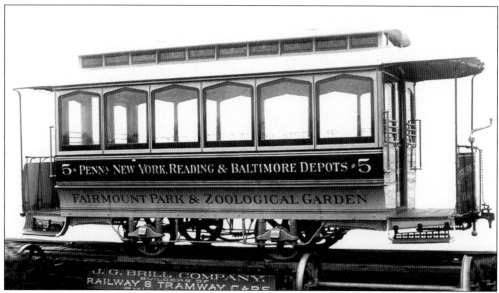

The popularity of this mode of transportation created many cottage industries, including trade magazines with the latest in designs. The J.G. Brill Company in Philadelphia built many horse-drawn vehicles. This photograph is a display of the Fairmount Park and Zoological Garden line, acquired from the West End Passenger Railway in 1873. (Courtesy of the John Gibbs Smith Collection at the Free Library of Philadelphia.)

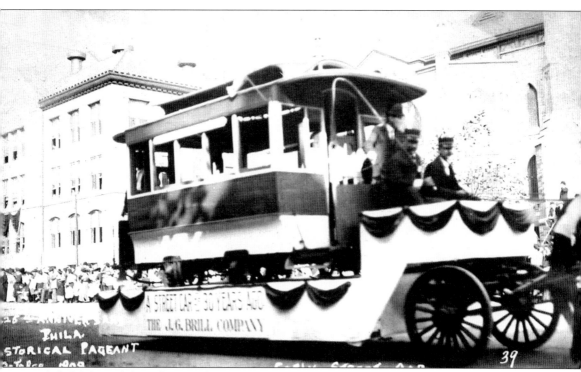

Philadelphia celebrated its 225th anniversary in October 1908 with a week-long affair. Parades and special events marked the passage of time. The familiar horsecar vehicle was on display in the parade atop a horse-drawn float. (Courtesy of the John Gibbs Smith Collection at the Free Library of Philadelphia.)

The end of an era did not mean the disappearance of horse-drawn vehicles. Collectors of the past bought old vehicles and stored them for various reasons in their backyards. A Second & Third Street railway car (No. 375) is stored on the property of a city resident along Germantown Avenue near Robert's Hollow, north of Southampton Avenue, c. 1900. (Courtesy of the Robert T. York Collection.)

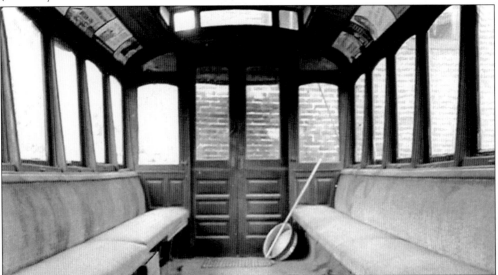

This rare photograph of the inside of a horse-drawn vehicle from the late 19th century reveals the rustic nature of the times. The simple wooden interior's many windows allowed plenty of light into the passenger compartment. Note the use of early advertisements on the curved portions of the car. Another light source came from the design of the clerestory roof. The sliding doors kept the elements out. (Courtesy of the John Gibbs Smith Collection at the Free Library of Philadelphia.)

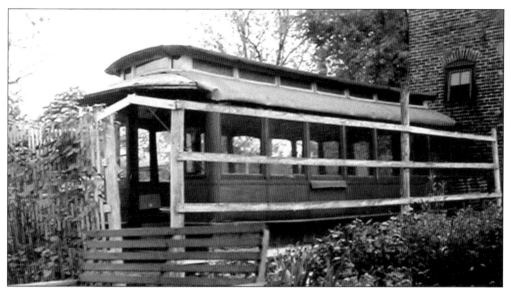

Many of the old horsecars survived as relics of the past and were blended into the urban and suburban landscape for other uses. This car was used in a Chestnut Hill backyard as part of an elaborate garden layout. This makeshift gazebo enhanced the outdoor scene and provided a picturesque photograph opportunity in 1941. (Courtesy of the John Gibbs Smith Collection at the Free Library of Philadelphia.)

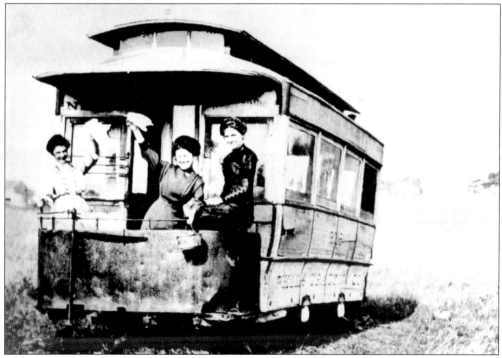

The women wave from an abandoned horse-drawn vehicle (No. 315) located in a farmer's field in the far reaches of Northeast Philadelphia at Rising Sun and Adams Avenue in the early 1900s. The relic perhaps gave farm hands shelter from the weather as they tended the field and certainly made for a fun activity for visitors, too. (Courtesy of Andy Maginnis.)

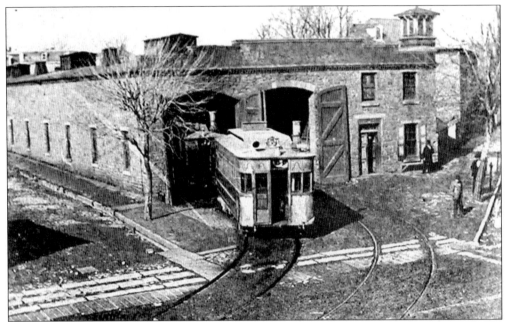

The replacement of the horse-drawn omnibus and street railway car became a dream of the industrial men of Philadelphia during the height of the Civil War, in 1863. Coming out of the carbarn at Arrott Street and Frankford Avenue are the two-cylinder, coal-powered vehicles named *Alpha* and *Seagull*, called steam dummies. This modern form of transportation lasted from 1863 until 1893 and ran in Frankford and the West Philadelphia suburbs. (Courtesy of the Frankford Historical Society.)

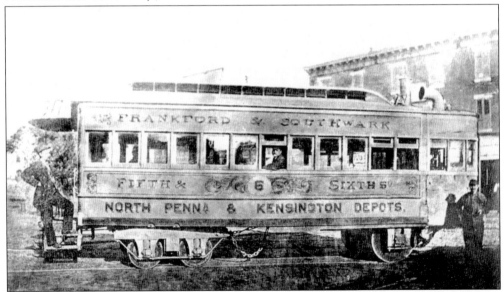

The new mode of transportation found in the technology of the late 19th century competed with the horse-drawn streetcars themselves. The steam dummies built by the Grice Company of New Jersey advanced the design of public transportation. The Frankford-Southwark line was the only line running above the Kensington depot to Frankford. (Courtesy of the New Jersey Electric Railway Historic Society.)

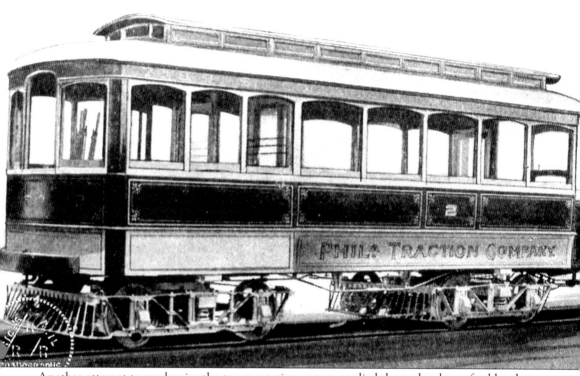

Another attempt to modernize the transportation system applied the technology of cables that wound in a conduit below the ground to pull several cars loaded with passengers. The Union Passenger Railway experimented with cable cars that ran from Forty-first Street and Haverford Avenue across the Market Street Bridge east to the ferries at Front Street and Delaware Avenue. Philadelphia joined the 29 cities using cable cars in the 1870s, due to a disease (Epizootic) that attacked the respiratory systems of 2,250 horses in the city. Cable cars served Philadelphia until technology gave way to the electrification of the streetcar in the 1890s. (Courtesy of Joe Mannix.)

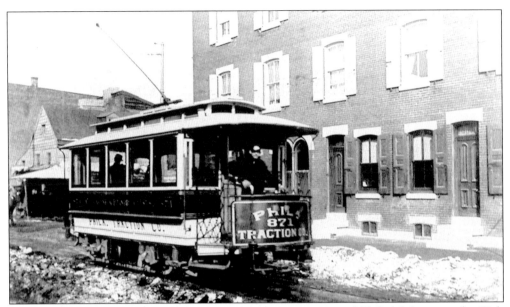

The innovations of the electrified street railway system projected Philadelphia into the 20th century. Resistance to the new technology came from the citizens who believed the popular notion of human hearts stopping and wristwatches doing the same when exposed to electricity. The city fathers overruled and granted new charters to allow railway companies to modernize. The first electric streetcar ran on the Catharine-Bainbridge Street line in 1892. (Courtesy of the John Gibbs Smith Collection at the Free Library of Philadelphia.)

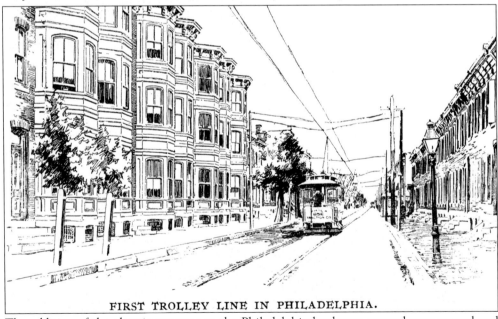

FIRST TROLLEY LINE IN PHILADELPHIA.

The addition of the electric streetcar to the Philadelphia landscape seemed very natural and contemporary. The building of new homes in the city reflected a modern approach to daily life. Open bay windows were the theme of many builders in the Victorian age and originated in the Civil War era. In this street scene from the perspective of 2300 Catharine Street, notice the gas light post to the right. (Courtesy of Joel Spivak.)

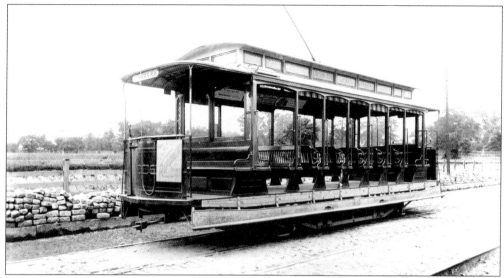

The 1890s were filled with joyful and carefree summers with rides along scenic routes in still-rural Philadelphia. The People's Traction Company car No. 258 ran on Girard Avenue from the Philadelphia Zoo in West Philadelphia at Thirty-fourth Street and Girard Avenue to Gunner's Run at Third Street and Girard Avenue. The car, built by the St. Louis Company in 1894, ran very smoothly with its electric motors under the passengers' feet. (Courtesy of Andy Maginnis.)

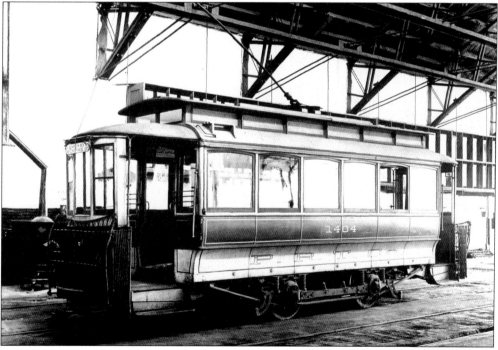

Some horsecar vehicles were outfitted with electric motors for service in Philadelphia. More carbarns were built to house the growing number of trolley cars. The new rolling stock included rope fenders to catch people or animals in the car's path, which are folded up in this photograph. Another change to vehicle design came with the development of the all-inclusive enclosed motorman's cab section. (Courtesy of Duke-Middleton.)

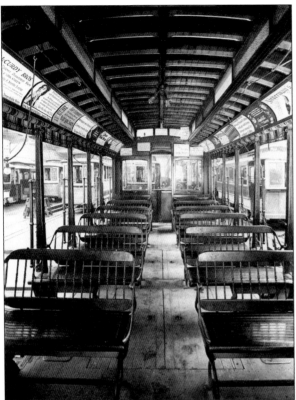

The electric car design provided new innovations in vehicle layouts. This open-air car is built with seating on both sides of a center aisle. The seats were reversible. The conductor had to flip over the reversible seats, called "walkovers." Roll-down screens that shielded sun glare were also installed for passenger comfort. (Courtesy of the Robert T. York Collection.)

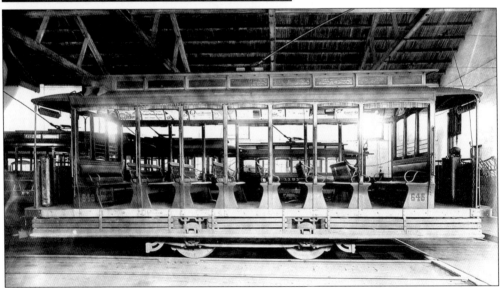

The fully accessible seats on this open-air trolley were monitored by the conductor for new additions aboard. This trolley adopted a single-wheel drive for each axle. The new wooden-framed trolleys did not have seatbelts or straps to hold onto during the ride. This trolley, parked in the Twenty-seventh and Girard Avenue carbarn, is being loaded onto another track via a transfer station mechanism. (Courtesy of the John Gibbs Smith Collection at the Free Library of Philadelphia.)

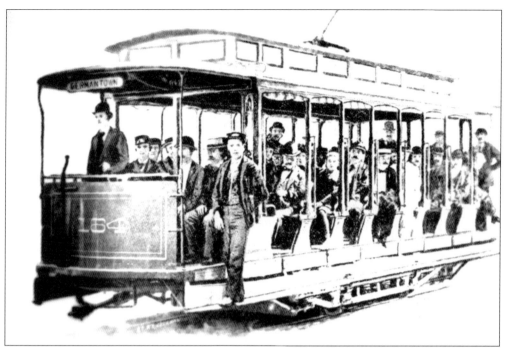

Open-air car No. 164, fully loaded with passengers, traveled the community of Germantown with the aid of a motorman and a conductor. Easy access to this mode of transportation from many sections of Germantown in the far northwest quadrant of Philadelphia made living in this community easy and convenient. (Courtesy of the John Gibbs Smith Collection at the Free Library of Philadelphia.)

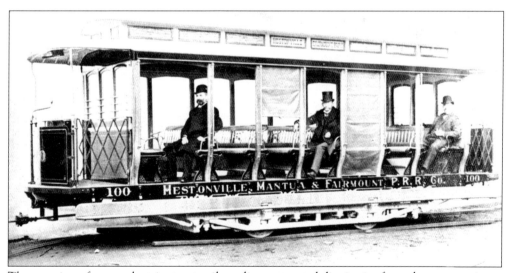

The opening of many electric street railway lines attracted dignitaries from the community at large. The fun of riding in an open car seemed almost magical to many people, especially those from West Philadelphia, where the Hestonville, Mantua and Fairmount operated in a semirural setting. Built by the Jackson and Sharpe Company in Philadelphia, the car went into operation in 1895. (Courtesy of Andy Maginnis.)

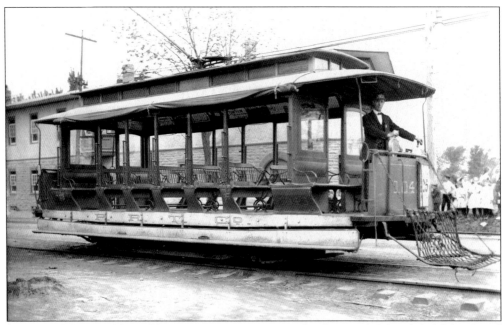

The consolidation of the public transportation system under the guise of the Philadelphia Rapid Transit Company (PRT) came in the early 1900s. All the railway lines were combined into one entity for stock sales, investment opportunities, and better management. PRT car No. 1043 operated in the northeast section of Philadelphia on Rising Avenue and was built by the McClintic and Marshall Company in 1907. (Courtesy of Bob Foley.)

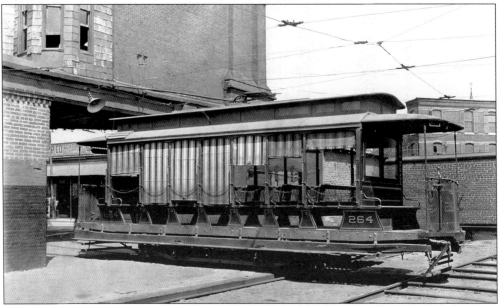

Decoration of the trolley car became a form of artwork as demonstrated in this photograph of open-air car No. 264, with its fancy, striped awning draped to protect the riders from the weather. This car, built by the Lamokin Company in Chester, Pennsylvania, is moved at the carbarn at Forty-third Street and Lancaster Avenue via a transfer table from one track to another. (Courtesy of the John Gibbs Smith Collection at the Free Library of Philadelphia.)

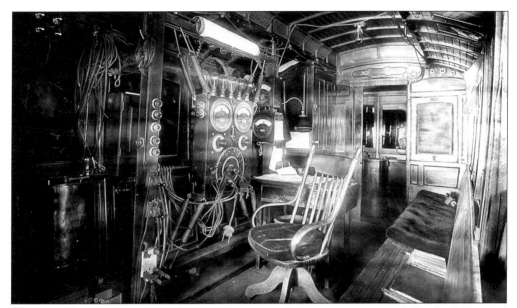

This rare photograph gives a glimpse of the complex instruments tested for durability and stability in electric railway cars at the turn of the 19th century. The dials gauged the flow of electricity from the electric motors. The three-legged swivel chair made it easy for the operator to switch his attention to any display panel. (Courtesy of the John Gibbs Smith Collection at the Free Library of Philadelphia.)

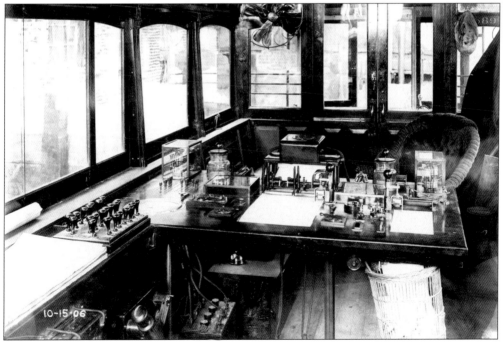

New developments were made as more electric streetcars were introduced. Enclosure of the passenger compartments began. The first form of air conditioning—an electric fan—arrived, although a horseshoe above the doorway reminded people of the recent past, when the horsecar was king. (Courtesy of the Robert T. York Collection.)

27

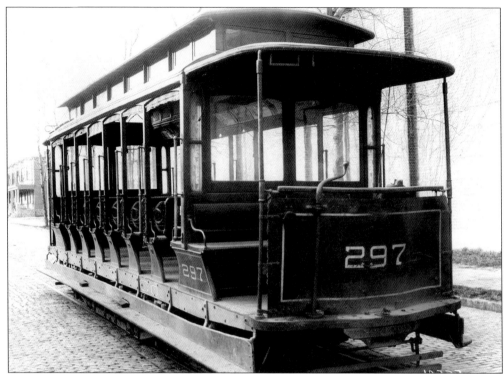

The multitude of open-air cars flooded the market for frequent trips in West Philadelphia during the late 1890s. West Philadelphia Passenger Railway car No. 297 ran along Fifty-second Street from the Bartram Botanical Gardens to Parkside. The new braking device shown in this photograph allows the motorman to stop the vehicle with a turn of the wrist. (Courtesy of Andy Maginnis.)

The need for better equipment, coupled with an increase in trolley car production in Philadelphia, produced many innovations. The front platform of No. 757 displayed a mounted windshield. Access to the car's passenger compartment was gained through sliding bifold doors. The rope fender became a relic of the past with the addition of the Hudson-Bowering (HB) fender, originated in Great Britain. (Courtesy of the Robert T. York Collection.)

Two
PHILADELPHIA BUILT

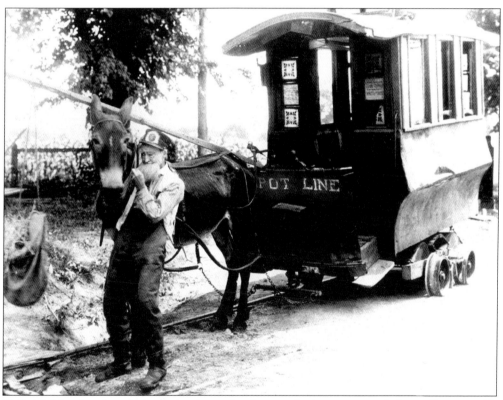

Philadelphia played a vital role in the technology and advancement of the trolley car with many companies competing for market share in this new industry. Innovation after innovation made the trolley car a safer and better form of public transportation. In the early 1900s, Philadelphia earned the reputation of "the trolley capital of the world." Siegmund Lublin, a Russian immigrant to Philadelphia, made many films from 1897 until the early 1920s. Thus, Philadelphia also became the movie capital of the world. Lublin opened four studios to produce motion pictures that ran in his theater chain throughout the city. *The Adventure of the Toonerville Trolley* depicted the commuter's mishaps and misfortunes. Actor Dan Mason and his costar, Skipper the mule, touted the daily exercises of riders who experienced the breakdown of this earlier mode of transportation. (Courtesy of Joseph P. Eckhardt.)

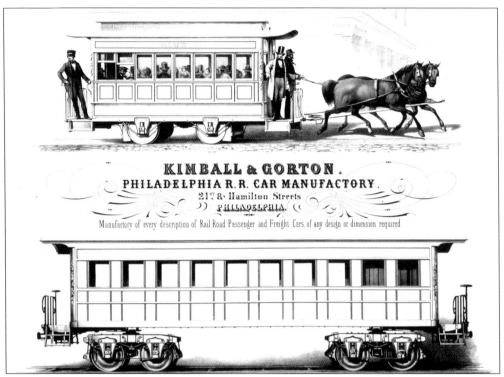

The Kimball and Gorton Philadelphia Railroad manufacturer advertised its products in many trade magazines throughout the country from its main offices at Twenty-first and Hamilton Streets. The new horse-drawn cars of the 1870s seated 20 passengers and weighed 3,300 pounds. (Courtesy of Joel Spivak.)

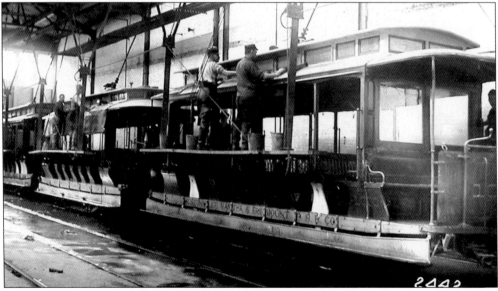

Some passenger railway companies bought cars and refurbished them in their own carbarns to meet their specifications. At the Woodland Avenue facility, the Hestonville, Mantua and Fairmount outfitted cars with oil-soaked canvas to protect their roofs. (Courtesy of Joe Boscia.)

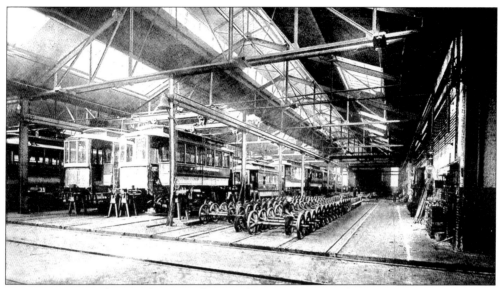

Horsecars were made into electric trolley cars by connecting two horsecars into one unit. The work done at the Kensington shop, located at Cumberland Street and Kensington Avenue, yielded a new product called the spiced car. The new combination cars sat on a chassis that had four double-wheel trucks to hold extra weight, in order to make extra money in transporting. (Courtesy of Malcolm Kates.)

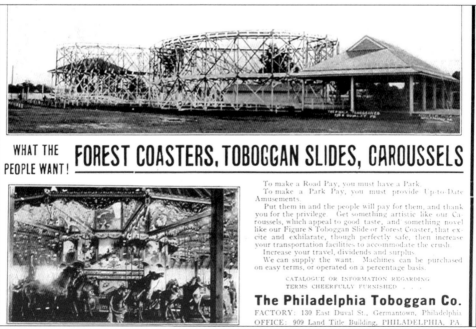

Philadelphia housed many manufacturers of wooden structural cars. The amusement parks in and around Philadelphia had components manufactured by the Philadelphia Toboggan Company, located at 130 Duval Street in Germantown. The motto of the day embellished this concept: "To make a road pay, you must have a park." The *Street Railway Journal*, including this advertisement, was published for the trade at its convention in Philadelphia in 1905. (Courtesy of Robert Skaler.)

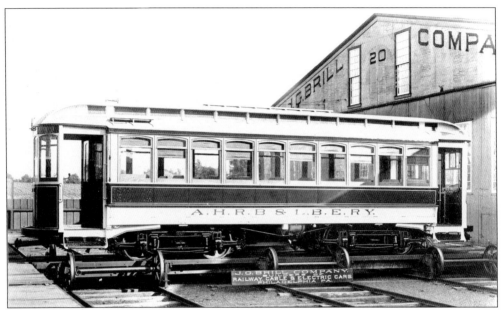

The large J.G. Brill Company at Fifty-eighth Street and Woodland Avenue in West Philadelphia manufactured more than 45,000 railway cars from 1868 until the 1930s. The assembly line consisted of many transfer tables to upright the new vehicle to the right track for its test runs on the streets of Philadelphia. The company made cars for many cities across the country. (Courtesy of Andy Maginnis.)

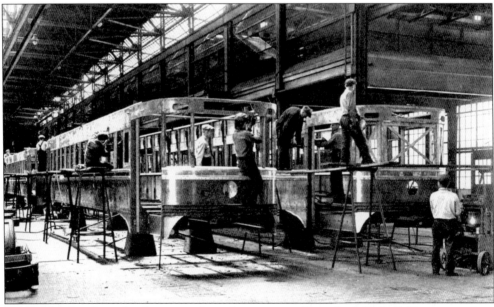

New technology kept developing in the industry, especially at the J.G. Brill Company, where aluminum became a favorite metal of choice for streetcar fabrication. The interurban railway cars on the assembly line were built for use on the Philadelphia-West Chester Traction Company. They could attain speeds of 80 miles per hour from the right-of-way at the Sixty-ninth Street terminal via the West Chester Pike to the county seat of Chester County in 1932. (Courtesy of Joel Spivak.)

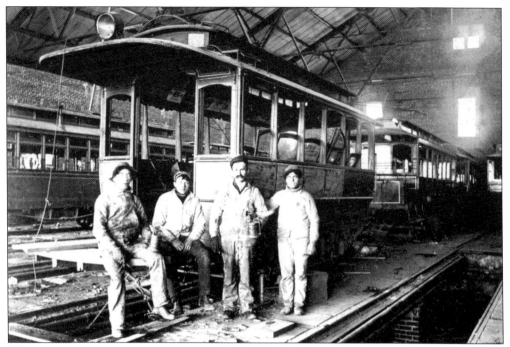

Workmen were kept busy throughout Philadelphia early in the second decade of the 20th century building and refurbishing trolley cars. This team, located in the Souderton carbarn northwest of Philadelphia, converts secondhand cars for use on the Chestnut Hill to Allentown interurban route via the Bethlehem Pike. (Courtesy of Andy Maginnis.)

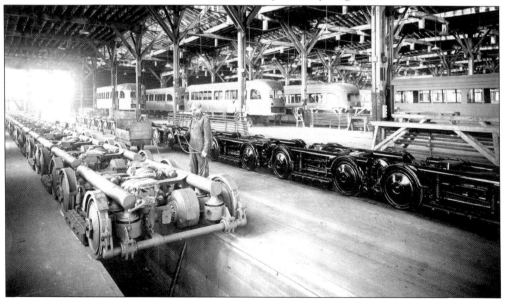

Streetcars in the modern era were made by the St. Louis Car Company in the 1930s. The modern cars known as Presidential Conference Cars (PCC) came on line after a group of presidents from urban transit companies met to discuss the plight of the trolley in light of the automobile's popularity. The streamlined design, fashioned after airplane technology, rallied the industry before the onset of World War II. (Courtesy of Jeffrey Marinoff.)

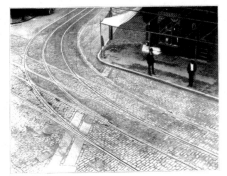

This advertisement from the *Street Railway Journal* touted a special rail layout at Twenty-ninth Street and Ridge Avenue, where several trolley car lines merged. The double-track configuration used the new manganese steel alloy in its design and manufacture process. The new steel allowed the bending and molding variation to better upright the trolley car. (Courtesy of Robert Skaler.)

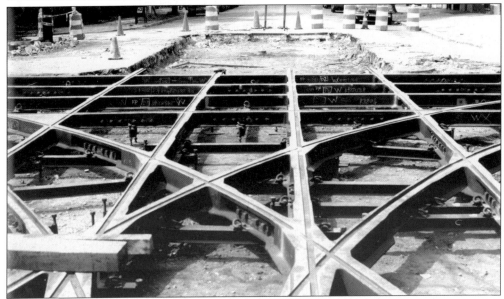

Track work throughout Philadelphia in the first two decades of the 20th century closed many intersections to vehicle and pedestrian traffic. The complex track work created by the Edgar Allen Company from England was laid at the intersection of Forty-ninth Street and Chester Avenue in West Philadelphia that serviced many trolley car lines, including the Route No. 13. (Courtesy of Jim Sparkman.)

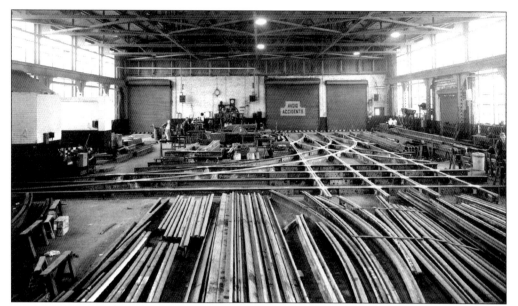

Components of rails were stored inside the Third and Courtland assembly track shop. The large, roofed facility provided the necessary workspace to lay out tracks in a realistic scale and setting. The mock-up for the intersection of nearby Fifth Street and Olney Avenue involved a large number of employees to measure and mark the connecting pieces at critical junctures. The tracks had to fit just right before installation. (Courtesy of Dennis Szabo.)

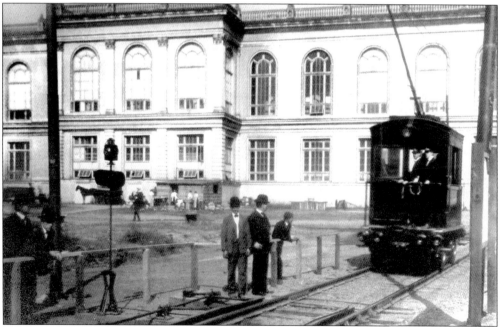

The Philadelphia Convention for Street Railways took place at the Commercial Museum, located at Thirty-fourth Street and Commerce Boulevard in West Philadelphia, on September 29, 1905. The featured exhibits were life-size models of new technology. The W. Wharton Jr. Company proudly displayed its "unbroken main line switch" as a temporary drop-in switch on existing track with no need for reconstruction. (Courtesy of Ed Gerschefski.)

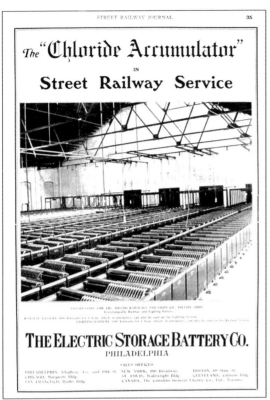

The ideas of the day were too numerous to describe in the forum of the convention. New power sources for the trolley car operation came in the form of a "chloride accumulator," better known as an electric storage battery, for car companies in outlying districts and regions. The Electric and Storage Battery Company at Nineteenth Street and Allegheny Avenue made the batteries for the Toledo, Ohio-based Railway and Light Company. (Courtesy of Robert Skaler.)

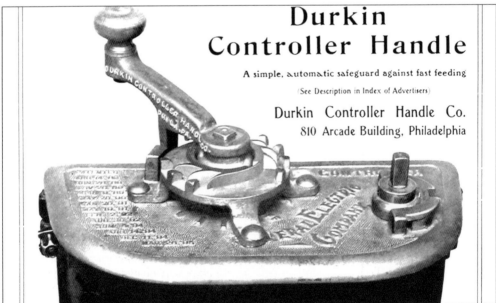

The process to harness the energy from the overhead electric wires spurred competition. The motorman, constantly regulating the acceleration and the feeding of power from the motor to the wheels, was helped with the innovative Durkin Controller Handle. Manufactured in the Arcade Building, it was a vital link in moving the trolley car continuously through the streets of the city. (Courtesy of Robert Skaler.)

A major breakthrough in rail technology occurred at the Philadelphia-based Lorain Steel Company in 1903. A new lightweight rail component, weighing just 137 pounds per three-foot section, made a major contribution to the expansion of the 554-mile web of tracks for Philadelphia's streetcar lines by 1909. (Courtesy of Robert Skaler.)

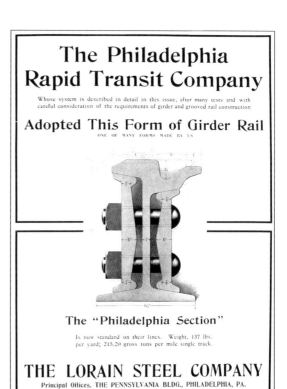

This engineering drawing explains the revolutionary change in rail design featuring an offset girder rail. The new design meant longer life and less expensive track replacement. The offset load design allowed the track to be moved inward toward the center, thus prolonging the life of the track itself. (Courtesy of Robert Skaler.)

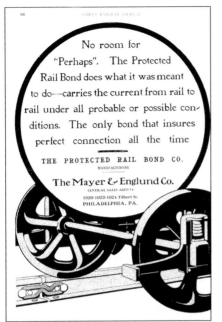

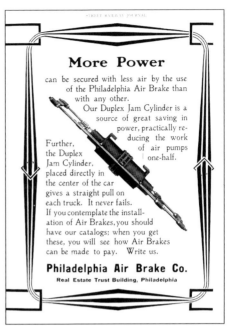

The Mayer & Englund Company (left) made electric bond parts for the St. Louis Car Company at its Philadelphia facilities. The electric bond provided a continuous way for the electricity to flow from the source and return back to the ground. The Philadelphia Air Brake Company (right) invented the duplex jam cylinder, which stopped all four wheels evenly with less wear. (Courtesy of Robert Skaler.)

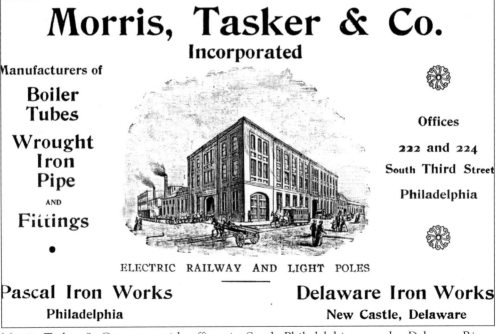

Morris, Tasker & Company, with offices in South Philadelphia near the Delaware River, provided the necessary upright poles that held the overhead wires in tension over the city streets. (Courtesy of Joel Spivak.)

The comfort of the passenger on longer rides via interurban travel attracted seat makers to upgrade their product for the street railways when they were electrified in the early 1890s. The padded seats of woven straw were only one product made by the Hale & Kilburn Manufacturing Company, the largest car seat company in the world. (Courtesy of Robert Skaler.)

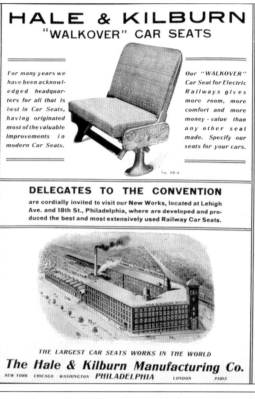

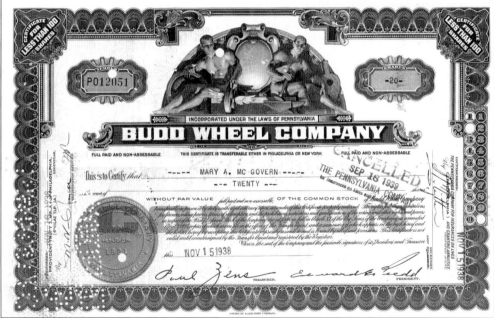

The well-known Budd Company originated as the Budd Wheel Company and was issued stock in 1938. The company's logo of a wheel with wings refers to the mythological Mercury, god of speed and motion. The adaptation came from Mercury having wings on his heels. (Courtesy of Joel Spivak.)

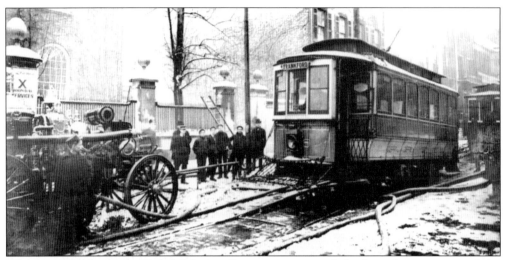

When a fire broke out in Philadelphia, trolley cars came to a halt along their routes until the St. Louis Car Company invented the fire hose jumper. The firemen arrived on the scene from the local engine houses and laid their hoses across the trolley tracks. Next, the transit employees assisted in the placement of the hose jumper equipment on the tracks and asked all the passengers to disembark until it had safely landed over the hoses. (Courtesy of the Philadelphia Fireman's Hall Museum.)

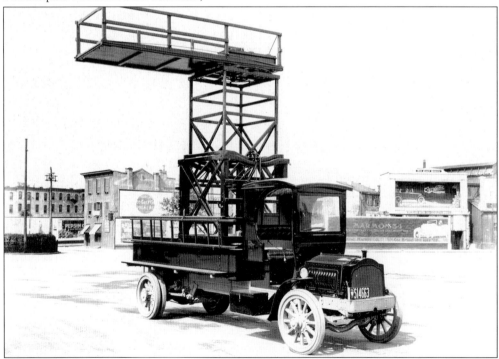

New ideas to service the trolley car industry originated in Philadelphia, with raw materials at hand. The introduction of trucks built by Henry Ford during the early 1900s made it possible to build an extension ladder apparatus tall enough to reach the top of the overhead wires for repair work. The trucks, when available, were used to carry firemen's hoses up and over trolley car wires at fire locations. (Courtesy of Bob Foley.)

Three
TRANSIT ARCHITECTURE

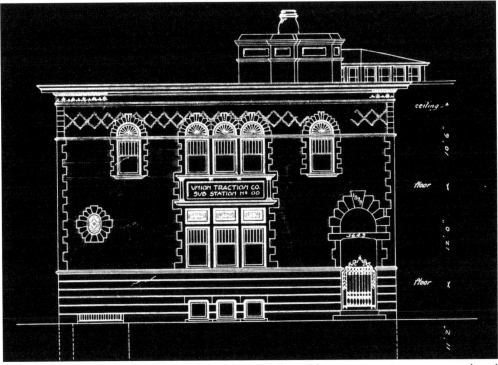

The construction of facilities that aided and served the public transportation system employed the use of many engineers and architects unknown to the general population. The designs were applied to waiting facilities; carbarns; housing offices; power stations; and repair, blacksmith, and paint shops. The horse-drawn railway era included the design of stables for many horses. A waiting area could be a simple three-sided shed with a bench, while others were heated and beautifully decorated buildings with modern restrooms. The carbarns started out as wooden sheds and evolved into large, precast concrete structures, sometimes one city block in size. The classic styles of architecture found in the late 19th century, such as the Moorish designs, highlight these facilities. The buildings often had the traction company's name inscribed in tablets above the main entrance. This blueprint shows the detail for the Union Traction substation at 3643 Germantown near Erie Avenue. (Courtesy of the Southeastern Pennsylvania Transportation Authority.)

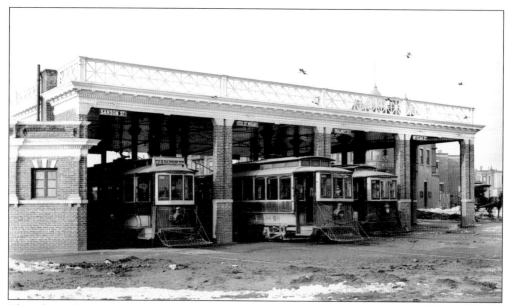

The Thirty-third and Dauphin Street depot provided shelter to riders via its four bays, wide spans, and tall piers. This building, a waiting room converted into a lunchroom, competed with the famous Cherry Pit across the street in the Strawberry Mansion section of North Philadelphia. (Courtesy of George W. Gula.)

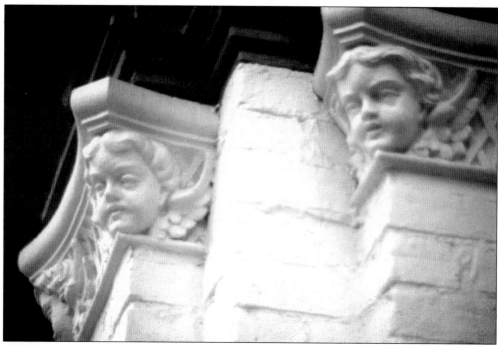

The accent on architectural style lent itself to neighborhood development and its fancy for attractive and practical buildings. The Thirty-third and Dauphin Street loop, built across from the Fairmount Park Trolley terminal in Fairmount Park at the turn of 19th century, is embellished with many cherubs atop the supporting columns. (Photograph by Joel Spivak.)

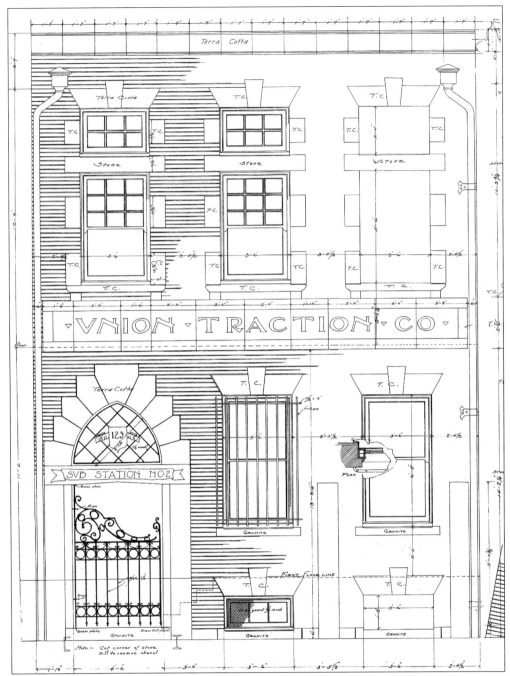

Storage Battery Station No. 2, located at 123 East Chelten Avenue, was built by the Union Traction Company in 1900 to reinforce the power supply for the Germantown trolleys. That gave way to a rotary converter station in 1904 under the auspices of the new PRT, which served as generator of electricity. The facility is shown here, with its attractive façade of terra cotta and brick with incised lettering on fictive ribbon under a Gothic transom window. (Courtesy of SEPTA.)

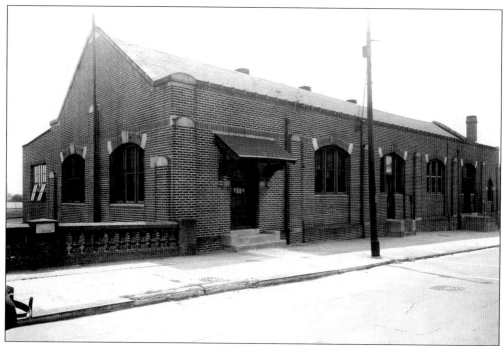

The Wyoming Avenue instruction office, built in 1908, contained classrooms for new motormen. The oversized timber work held up a shed roof over the entrance. The segmental-shaped arches repeated in the pier caps, and the brick façade blended in with the architecture of the surrounding community. (Courtesy of Andy Maginnis.)

The new Market-Frankford Elevated provided many buildings their upstart in the early 1920s. The offices of the Philadelphia Rapid Transit Company were built in 1922 at the end of the Frankford line. The hipped roof, with its deep overhang, plus dormer windows added to the beauty. Rounded arch windows with stone imposts and a keystone are typical of the contemporary style of architecture.

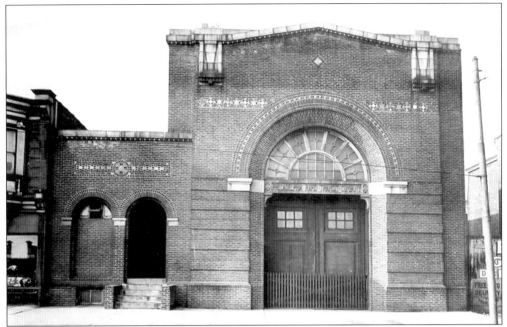

The Fifty-eighth and Woodland Avenue substation was built by PRT in 1907 to supply power to West Philadelphia trolley lines. The building supplemented the power station at Thirty-third and Market Streets. The contemporary building is brick with terra cotta and inset tiles. (Courtesy of Joe Boscia.)

Substation construction is full of neat details. The over-scaled ornamental terra cotta inset tiles are unique in the area of Fifty-eighth Street and Woodland Avenue. The egg and dart frieze across the top of the building is freely done and embellishes the entire structure. (Photograph by Joel Spivak.)

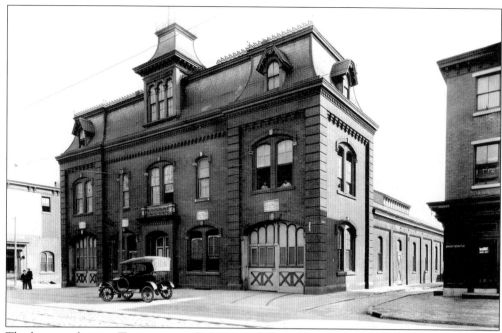

The horsecar barn at Twenty-seventh Street and Girard Avenue, built by the Delaware River Passenger Company in 1864, is one of many buildings in the area. The structure featured a concave mansard roof with iron cresting (metalwork) and wide segmental relieving arches over paired windows. Channeled corner piers with a corbeled frieze are featured above the top of the building. (Courtesy of Dennis Szabo.)

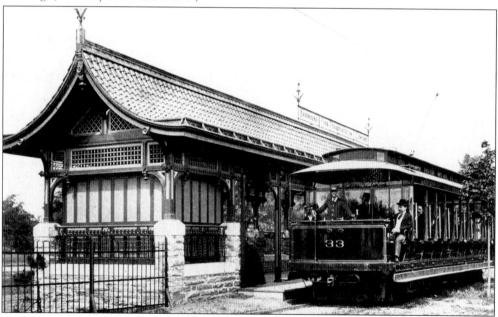

The Fairmount Park trolley car waiting room at Thirty-third and Dauphin Streets is an elegant Victorian structure with Japanese influence, featuring a concave gabled tiled roof with remarkable iron cresting. Note the latticed framework between the stone and wood structural members. The building enticed people to come and explore the ride itself. (Courtesy of Joel Spivak.)

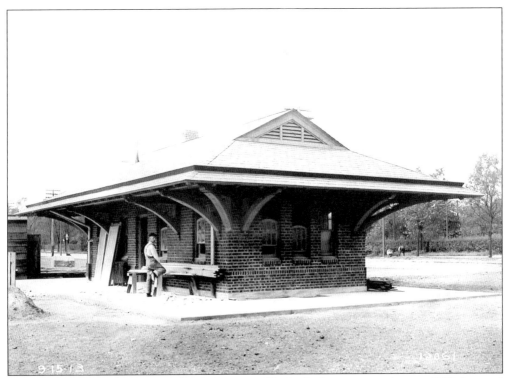

The large waiting room at Forty-fourth Street and Parkside Avenue, seen here c. 1913, featured indoor plumbing and heat for passengers eager to board the Lombard-South Street line. The low, half-hipped roof with deep eaves supported by large curved brackets for extra support is found in this 1910-era Edwardian design. (Courtesy of Joe Boscia.)

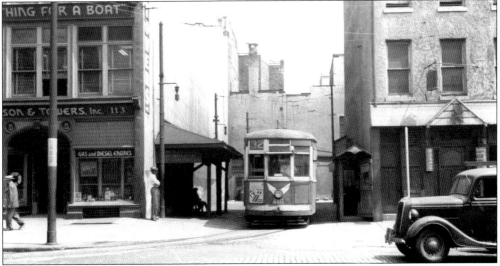

This c. 1948 photograph shows a breezeway, or opening between buildings, which is a Philadelphia tradition. Trolley cars made loops around the buildings at 111 Market Street on their return trip uptown. The hipped shed against the party wall provided shelter from the weather for riders. Note the frontal gable roof on the watchman's shed on the right. (Photograph by John Roden; courtesy of Joel Spivak.)

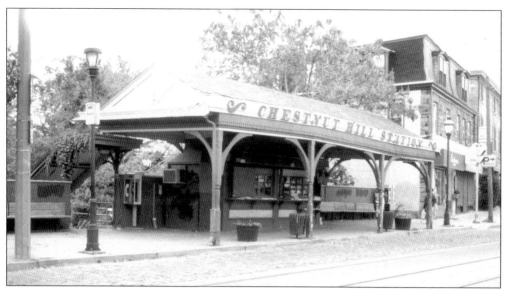

Passengers departed from the Pennsylvania Railroad terminal to street level and waited in the Chestnut Hill shelter for the trolley car on Germantown Avenue and Bethlehem Pike going southbound. The gable roof is supported by chamfered curving brackets over wide spans with king post end gables. (Photograph by Joel Spivak.)

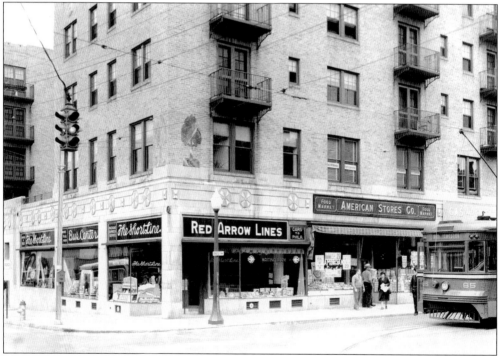

The Red Arrow suburban transportation line on the western boundary of Philadelphia provided a comfort station inside an existing storefront at the end of the West Chester interurban railroad. The trolley car from the Sixty-ninth and Market Street terminal took passengers on a scenic, one-hour ride through the countryside. The heated facilities at High and Gay Streets in West Chester included a ticket agency. (Courtesy of Bob Foley.)

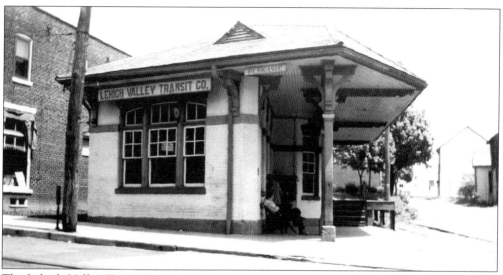

The Lehigh Valley Transit Company waiting area in Perkasie was located 20 miles northwest of Philadelphia and was designed by Wallace Ruhe and Robert Lang of Allentown. The structure included a freight storage area and loading platform. The building featured an unusual roof with deep eaves and heavily bracketed posts. (Courtesy of Andy Maginnis.)

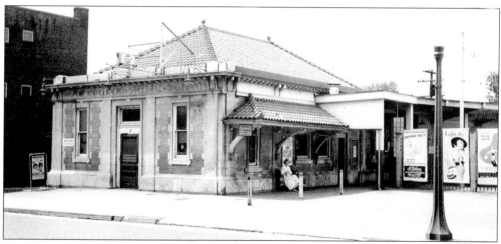

At the end of the trolley car line from Sixty-ninth Street serviced by the Ardmore-Llanerch Street Railway, Ardmore Station provided shelter in the winter and summer from extreme weather conditions. The rich classical architecture involves a lettered frieze and framed window openings surrounded by terra cotta quoins. (Courtesy of Richard Short.)

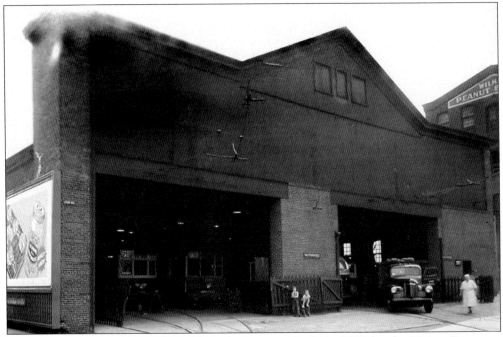

The large carbarn at Hancock and Lehigh Avenues, built in 1886 by the Union Passenger Railway, served as a shelter for vehicles and as a stable. Electric streetcars were stored here until 1913, when the building was converted into a paint and repair shed that was in use until 1957. The plain brick piers supported wide spans, and the upper story is sheathed in vertical wooden boards akin to agricultural barns. (Courtesy of Joe Boscia.)

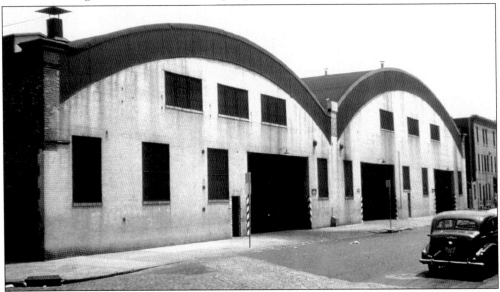

The Sixteenth and Jackson Street carbarn, in the middle of a South Philadelphia neighborhood, reminded people of the user-friendly nature of public transportation. Built by the Philadelphia Traction Company in 1895, the facility served as a shelter for its trolley cars. The structure, seen here c. 1955, is highlighted by a pair of broad, segmented arch spans with a common party wall. (Photograph by Joe Mannix.)

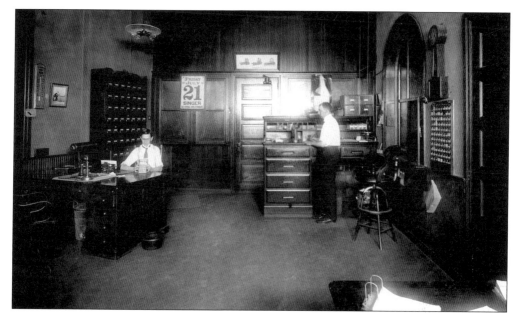

Carbarns had several facilities under one roof. This rare interior photograph of the Eighth and Dauphin Street offices reveals a very neat and organized administration. The wood-paneled room and its many filing cabinets made it easy for the clerk to file daily items. (Courtesy of the Robert T. York Collection.)

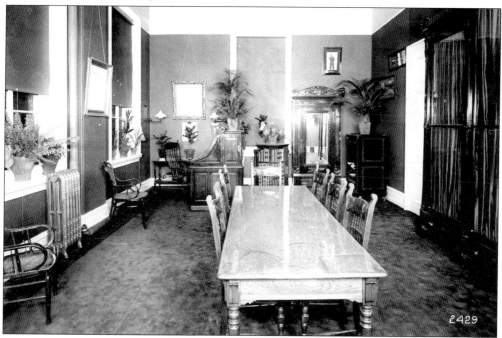

Each railway company, up until the consolidation of the lines into the Philadelphia Rapid Transit Company (PRT), was fiercely independent. In this view, the conference room at Eighth and Dauphin Streets is highly decorated for the Victorian era with ornamentally carved, framed mirrors and Brentwood chairs. A modern radiator system was later added. (Courtesy of the Robert T. York Collection.)

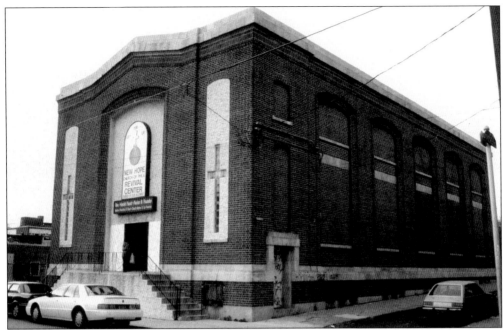

This substation, designed to blend into the surrounding urban landscape at Fifteenth and Tucker Streets below Lehigh Avenue, was built by PRT in 1912 and provided relief for the Thirteenth and Mount Vernon Street powerhouse. The structure included gigantic segmental arches climaxed with a segmental archway in the gabled end. The building ultimately became a church and still serves the community. (Photograph by Joel Spivak.)

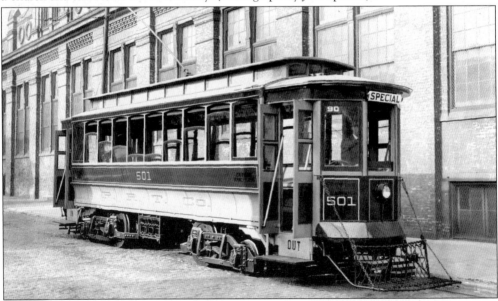

The Kensington carbarn at Kensington Avenue and Cumberland Street, built by the Frankford-Southwark Passenger Railway Company, opened in 1871. The architecture of the post–Civil War era involved a corbeled frieze between the pilasters and crowned with a tripartite decorative attic. The ornaments were crested with pediments and a frieze of four circles. (Courtesy of Bob Foley.)

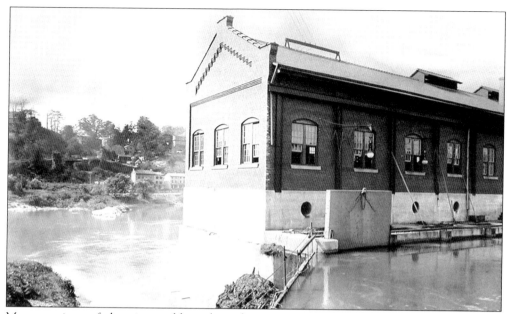

Many sections of the city could produce their own power, given the natural resources of Philadelphia. The Manayunk substation alongside the Schuylkill River Canal was built by PRT and opened in 1905. The Philadelphia hydroelectric plant near Main and Levering Streets supplied power to Ridge Avenue lines. The structure, with a simple gable roof, featured light monitors riding the ridge of the roof. (Courtesy of Joe Boscia.)

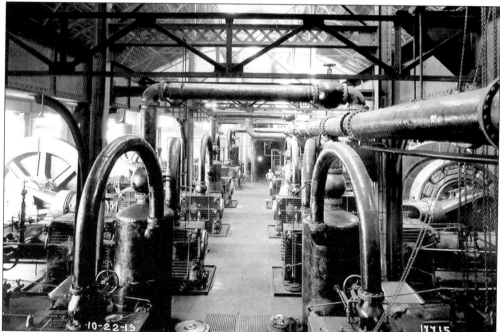

Power plants for the trolley car system employed the best technology of the industrial age. The inside of the Manayunk substation in this 1919 photograph displays the latest in hydroelectric power plant equipment. The facility became a hub for Mrs. Paul fish products in the 1950s. (Courtesy of Joe Boscia.)

This aerial view of Thirty-third and Market Streets includes a microscopic glimpse of what propelled the trolley car system over the last 100 years. The substation to the extreme right, built by the Philadelphia Traction Company in 1894, gave way to the building that housed a rotary converter in 1908. By 1972, the ground work was laid in the far left for a new building to hold a solid state unit to power equipment, just the size of two filing cabinets. (Courtesy of Andy Maginnis.)

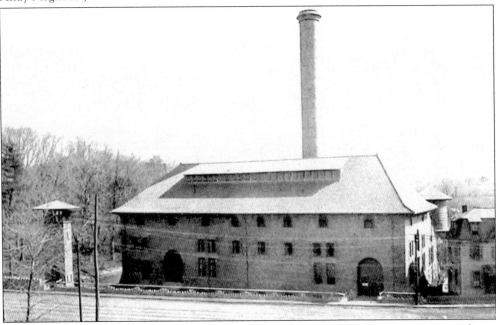

The Ogontz powerhouse, located along the Cheltenham and Willow Grove Turnpike at Church Road in Elkins Park, provided the energy for the Willow Grove trolley car system in the early 1900s. The large building is treated with flaring eaves that call to the small tower at the left. The building was demolished in the 1940s to allow for the relocation of Old York Road through the mountain. (Courtesy of the Old York Road Historic Society.)

Four

AMUSEMENT PARKS

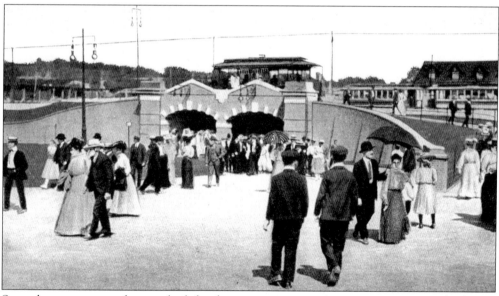

Several amusement parks were built by the various transit companies to increase ridership on the weekends. A destination out of the hot city of Philadelphia in the summer provided welcomed relief. Amusement parks helped to expand the population out to various sections of the city, including Mingo Creek in the southwest, White City in the northwest, Woodside Park west of the Schuylkill River, and Soupy Island, a nickname given to the area in South Philadelphia at the end of Point Breeze Avenue. This 1896 postcard shows the entrance to the Willow Grove Amusement Park, built by the People's Traction Company and described to all as "one good set of stage horses from Philadelphia." (Courtesy of Dennis Szabo.)

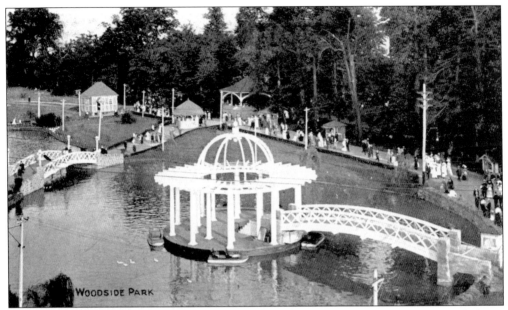

The Woodside Park Amusement Park, built in the romantic era of the 1890s, provided city dwellers with a great way to escape the heat and relax during the summer. The natural setting gave the Fairmount Park Transit Company a reason to construct a transportation system into the park and the Strawberry Mansion Bridge. Attendees were lured to the wonderful boat lake and its foot-accessible pavilion pier. (Courtesy of John Nieveen.)

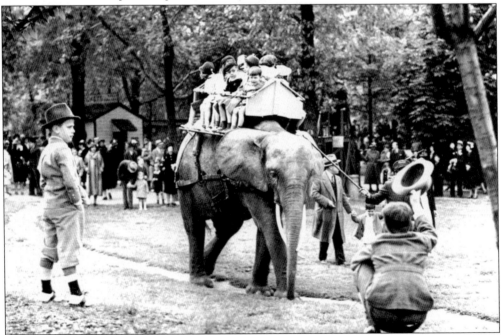

Excellent rides captured the imaginations of the people who visited Woodside Park. The patrons rode in a "howdy," or a compartment on top of the animal. Grownups and children alike based their memories on whole days spent in a magical space separate from the urban setting yet in its midst. (Courtesy of Andy Maginnis.)

The experience at Woodside Park turned and twisted everyone's body in an array of different directions on rides high above the ground such as the Wild Cat, the Hummer, the Lightening Bug, and the Chase the Duck water ride. The excitement and joy of the young people added up to a ball of fun! (Courtesy of Andy Maginnis.)

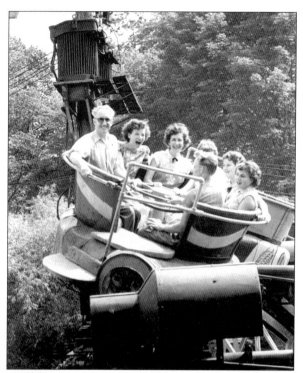

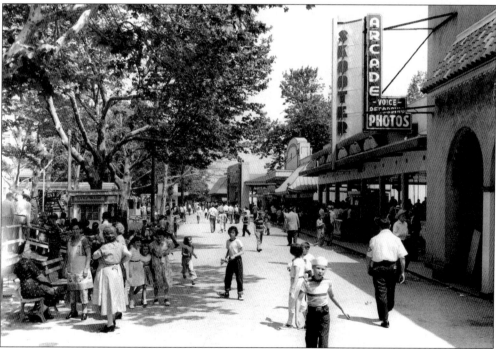

Once past the entrance to Woodside Park and Charlie the Laughing Clown, an attendee came upon the popular arcade, where he could ride the Skooter or electric bumper cars, have his photograph taken, or make a voice recording. No matter what was planned that day, it was an adventure waiting to unfold. (Courtesy of Andy Maginnis.)

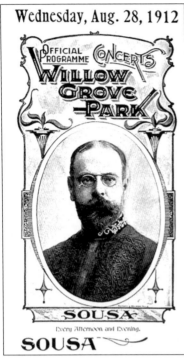

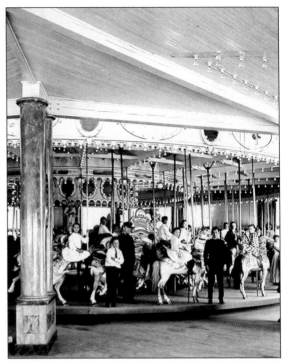

The attractions at the Willow Grove Amusement Park, only 15 miles directly north of Philadelphia along the extension of North Broad Street or Route No. 611, included concerts by the world-famous conductor John Phillip Sousa. The park also offered huge carousels that played music of the day and exhibited beautifully carved figures by local artists. (Courtesy of the Old York Road Historic Society.)

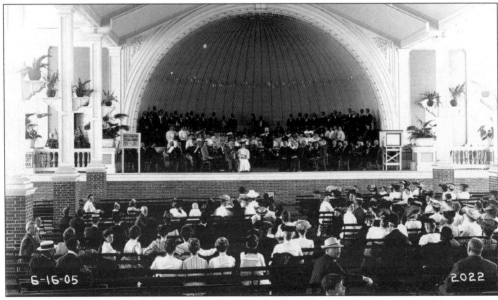

The entertainment in the evenings could be heard throughout the park courtesy of the acoustic effects of the band shell. People sat on wooden park benches or spread out on picnic blankets to enjoy the wonderful sounds of music. (Courtesy of Andy Maginnis.)

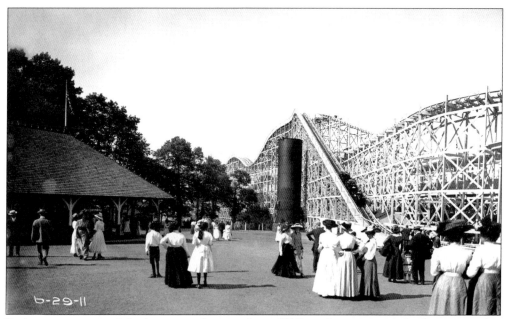

Each amusement park had its own claim to fame. Willow Grove touted the largest wooden roller coaster, named Chase through the Clouds, when it opened in 1904. The oversized pavilion provided a vast shelter from the sun and rain and featured electric lights at night. (Courtesy of Andy Maginnis.)

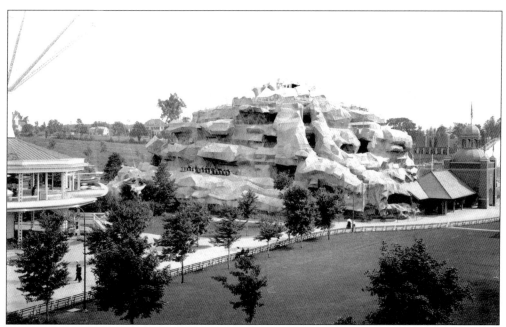

Amusement parks are known for their hair-raising rides. The long roller coaster named the Alps provided hours of thrills and produced wild calls from its riders. Designed by John Miller in 1905, it became the first coaster based on gravity drops and achieved the distinction of the longest running ride in America. The roller coaster closed down in 1957, when the park changed over to the Six Guns Territory theme park. (Courtesy of the Robert T. York Collection.)

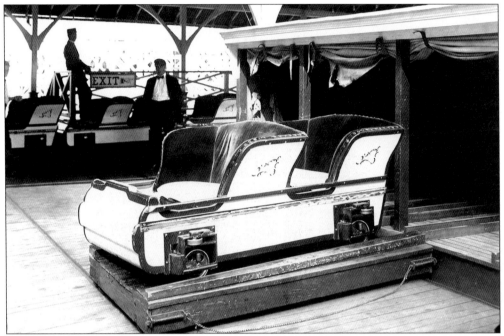

Rides at Willow Grove Park gave the patron a grand sense of enjoyment, especially as the new 20th century made its appearance. This close-up photograph shows the Little Scenic Car, which held four people and toured the park grounds high above. It was the longest scenic roller coaster in America, at 3,100 feet, when it opened in 1896. (Courtesy of the Special Collections at the Free Library of Philadelphia.)

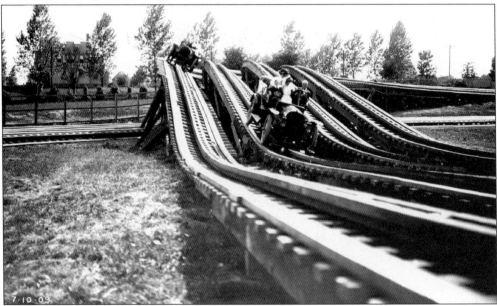

At the advent of the horseless vehicle known as the automobile, rides mimicked the current era and provided a first-hand experience of the future. The Auto Race Track debuted in 1909. The nine-passenger electric cars were advertised in this way: "Where the races run with none of the fears—all of the fun." (Courtesy of the Robert T. York Collection.)

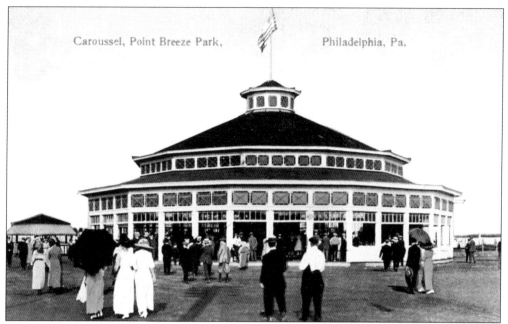

Carousse!, Point Breeze Park, Philadelphia, Pa.

Philadelphia housed the talent to create great attractions at its amusement parks. The Point Breeze Amusement Park, located west of Broad Street adjacent to the Schuylkill River where it met the Delaware, boasted of the largest carousel in America in 1906. The beautiful pavilion, with its many-sided facades, was constructed by the Dentzel Carousel Company from 3635 Germantown Avenue and employed wood carvers of Italian and Jewish heritage from South Philadelphia. (Courtesy of John Nieveen.)

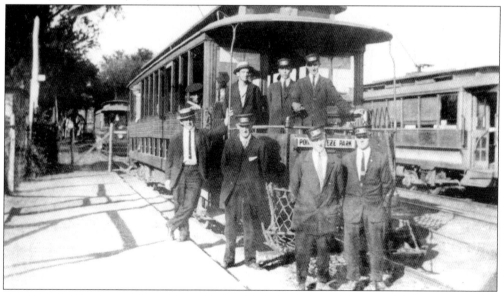

Motormen and conductors pose with their trolley cars at the entrance to the Point Breeze Amusement Park in South Philadelphia in the second decade of the 20th century. The arrival in the area of thousands of European immigrants provided the impetus to create the park. Trolley car rides were given gratis around the park as a lure for coming. (Courtesy of the Robert T. York Collection.)

Transit companies in the late 1890s and early 1900s built and operated amusement parks. The Philadelphia Rapid Transit Company had Willow Grove, and the Philadelphia and West Chester Railway operated Castle Rock Park. The Philadelphia and Western Railway, running from Sixty-ninth and Market Streets to Norristown, opened the Beechwood Public Amusement Park in Haverford Township, only six miles from Upper Darby, in 1907. The grand property and its many attractions was in view from the interurban electric railroad. (Courtesy of the Robert T. York Collection.)

The remains of a great dream and hope still exist today at Beechwood Station along the Philadelphia and Western high-speed line. Beechwood Park, only minutes from Philadelphia, previewed before the opening of the Market Street El in 1907. Coupled with several blunders, the park remained open for only one season due to the economic panic of 1907 and its location. (Courtesy of Dave Biles.)

Five

MY TROLLEY CAR

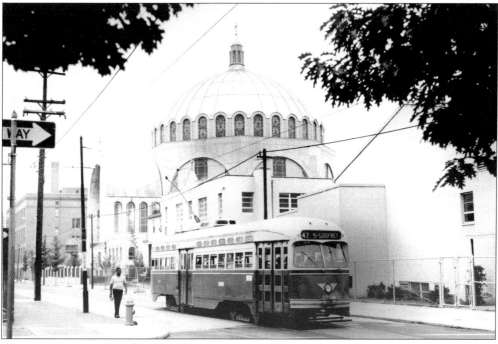

Many people not only rode trolley cars in their neighborhoods but felt a personal kinship to the piece of transportation that touched their daily lives. The familiar motorman and his smiling demeanor and the rider's favor seat (if it was not taken) both made the trolley a wonderful piece of Americana. Philadelphians came to rely on the trolley for trips to work, school, other neighborhoods, and Phillies ballgames at Twenty-second Street and Lehigh Avenue. The cost to ride the trolleys remained at a constant 5¢ into the 1940s. The streamlined Route No. 47 picks up passengers at Seventh and Parrish Streets in North Philadelphia in front of the gold-domed Ukrainian church. (Courtesy of Richard Short.)

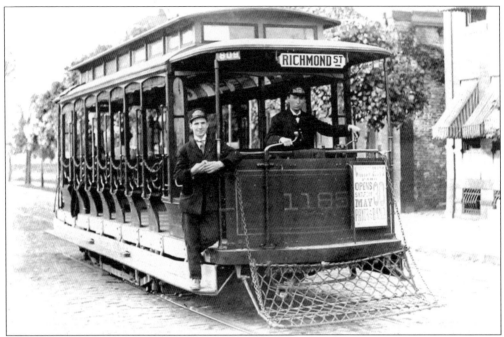

The neighborhood streetcars, affectionately known simply as trolleys, ferried workers throughout the city back and forth to their jobs. Motorman Joseph Berger, from the Strawberry Mansion section of the city, knew his way around and, though a recent Russian immigrant, was fluent enough in English to qualify as a PRT driver. (Courtesy of Joe Boscia.)

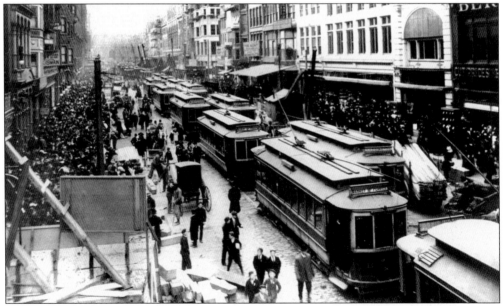

Market Street, shown here west of Tenth Street during the construction of the subway in 1907, seemed chaotic with so much traffic, animals, and vehicles. The 1900 version of the trolley car, known as the Philadelphia Standard, was altered after 1910 in order to let people pay within the car. Larger trolley cars sped riders downtown from all directions to shops and to work. (Courtesy of Andy Maginnis.)

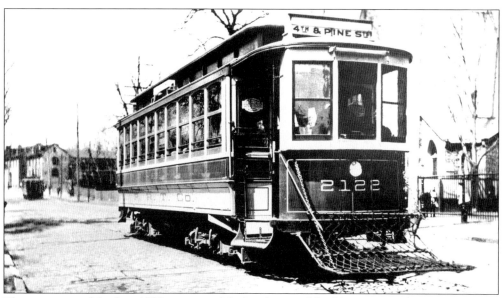

The open cars of the late 1890s were modified with a windshield to protect the motorman and to allow riders to pay at the doorstep. This photograph, taken in 1909 on Germantown Avenue, gives a great view of the improvement in street paving that accompanied the arrival of the trolley car. The rope fender, an invention to "catch people or animals" without bodily harm, was maintained for another decade. (Courtesy of Andy Maginnis.)

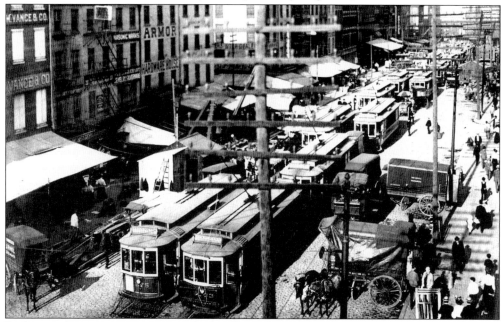

Rush time downtown set new records of trolleys whizzing by the busy Eighth and Market Street hub, where the Lits Brothers and Gimbels Brothers Department Stores competed for customers on an hourly basis. The new Philadelphia Standard cars, built by the J.G. Brill Company, made their debut in 1906. Eastbound trolley traffic accounted for 126 cars per hour, while trolley cars headed to all destinations radiated out of the downtown area at 166 trolleys per hour. (Courtesy of Andy Maginnis.)

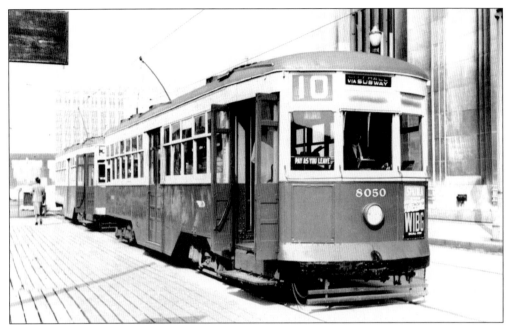

West Philadelphia, a city within a city connected to the downtown district, accounted for a large ridership. The Route No. 10 passes the Thirtieth Street Railroad Station north of Market Street, built in the 1930s to accommodate rail traffic to destinations south and west of Pennsylvania. This 1952 photograph shows a car from the 8,000 series, originally built by the J.G. Brill Company from the 670-trolley-car order. (Courtesy of Richard Short.)

Trolley lines in Philadelphia developed and won contracts to connect outlying cities with Philadelphia. The heavy-duty design of the truck assembly, with entrances at the front and rear, typified the Hog Island car. It ferried workers from Chester south of Philadelphia to the Hog Island Shipyard during World War I. The men brought homemade sandwiches loaded with lunch meats, lettuce, and tomatoes, now a Philadelphia favorite known as the Hoagie. (Courtesy of Bob Foley.)

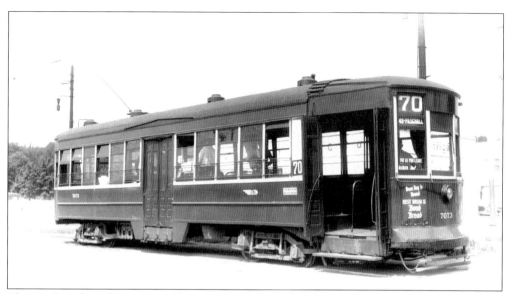

The north and southbound workhorse route of West Philadelphia, known as the Route No. 70, ran from the Forty-ninth and Woodland carbarn along Fifty-second Street with connections at the Market Street Elevated. The nearside car went by many neighborhood parks and movie theaters, including the Locust, the Nixon, and the Capital, on its way up to the Wynnefield section of Philadelphia. It made its loop at Fifty-fourth Street and City Line Avenue, where a large Horn and Hardart cafeteria awaited everyone. (Courtesy of Richard Vible.)

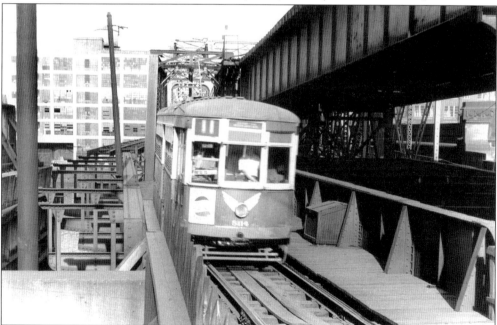

Rides on the West Philadelphia trolleys made for an adventure all by themselves. The massive bridge for the Market Street Elevated had adjoining side rails for trolleys that crossed the large Schuylkill River. The Route No. 11 trolley went underground into the subway tunnel for access to city hall and served the residents of West Philadelphia who lived south of Market Street. (Courtesy of Andy Maginnis.)

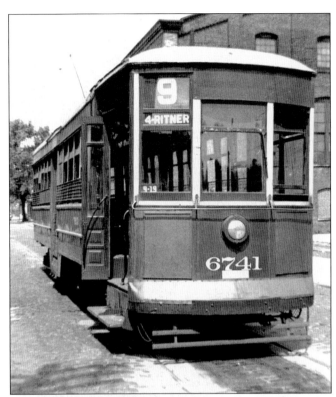

The most romantic trolley in Philadelphia belonged to the Route No. 9, which wove its way from deep in South Philadelphia to the Strawberry Mansion section in North Philadelphia. When the Jewish population migrated from South Philadelphia to the area near Fairmount Park, the line on Sunday trips was referred as "the Jerusalem Express." The line stopped running in the late 1950s, when neighborhoods shifted populations to newer sections of the city. (Courtesy of Richard Short.)

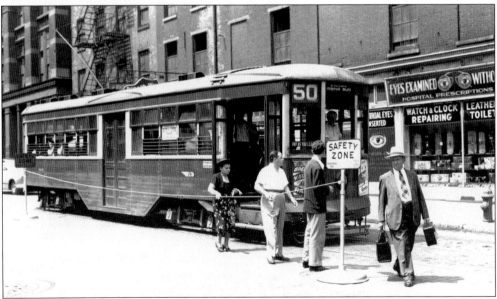

North and South Philadelphia trolley routes were very long and twisted through many neighborhoods, with full loads during peak periods. The familiar Route No. 50 went from Fourth and Ritner Streets through the Italian and Jewish neighborhoods, up Fifth Street in the heart of the industrial sections of Philadelphia, before terminating more than 20 miles into the northeast section of Philadelphia known as Fox Chase. This 1948 photograph at Fifth and Market Streets preceded the Independence Mall era. (Courtesy of Richard Vible.)

The Route No. 23 served as one of the longest lines in Philadelphia, stretching from Tenth and Bigler Streets near the city dumps in South Philadelphia to Eleventh and Twelfth Streets and crossing North Broad Street at Erie Avenue on its climb up Germantown Avenue. Its decorative passenger shelters ended in Chestnut Hill. The Route No. 23 was popular for the safe and easy ride via one trolley into the downtown district to the Reading Railroad terminal and the farmer's market at Twelfth and Market Streets. (Courtesy of Michael Szilagyi.)

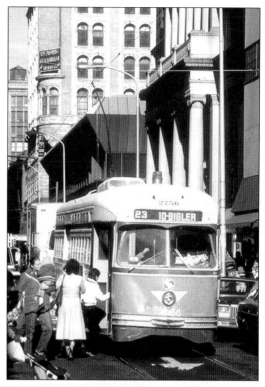

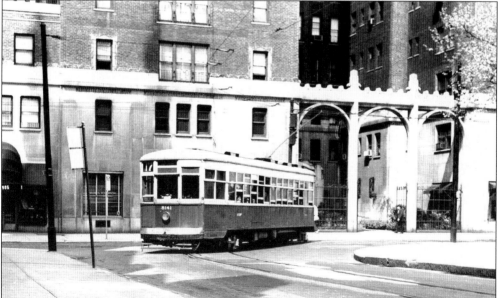

North and southbound trolley lines ran parallel to North Broad Street. The Route No. 17 originated in South Philadelphia at Nineteenth and Johnson Streets and claimed the Southern Depot as its home. The line winded its way around the fashionable Rittenhouse Square section, seen here c. 1957, at Nineteenth and Walnut Streets after its trip to the downtown district. It then looped around at Front and Market Streets to meet the Delaware River ferries. (Courtesy of Andy Maginnis.)

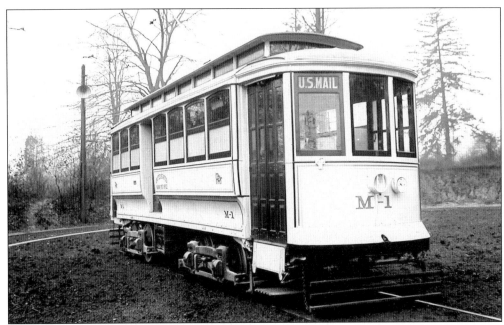

Specialty trolleys are rarely known in Philadelphia, although they existed and served a daily task. The mail must get through in all types of weather and modes of transportation. This United States Mail car delivered to the far reaches of West Philadelphia toward the Overbrook section of the city. The spliced-type car is actually two cars made into one, and the M-1 shown here is parked at the layover loop at Seventy-first Street and Haverford Avenue. (Courtesy of Joe Boscia.)

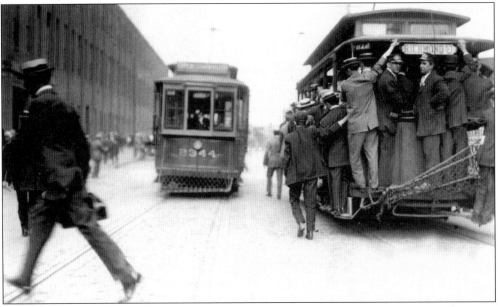

Although the trolley served an important function in the daily lives of the city residents, its true value lay in the fun that everyone had getting to and from work or school. Hopping a trolley in the 1920s meant hanging on for dear life, and standing room only was the order of the day. (Courtesy of the Bridesburg Historical Society.)

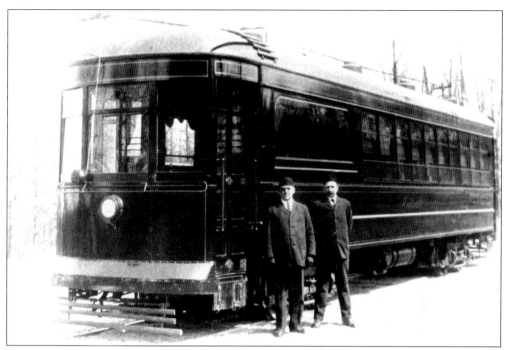

For the Jewish community concentrated in South Philadelphia, the Montiefore Burial Ground in Rockledge, Pennsylvania, beyond Fox Chase, was made accessible by the Route No. 50 trolley. The special service trolley car (shown here in 1910) contained a compartment for the casket, and the mourners escorted the body on the Hillside cars from 1912 to 1932. (Courtesy of Dennis Szabo.)

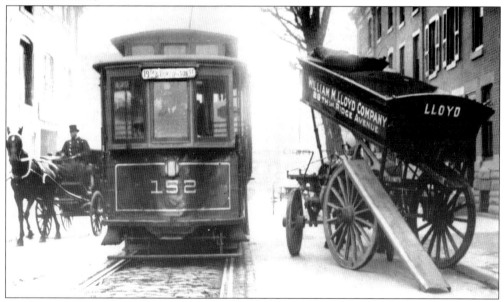

The narrow streets of Philadelphia were cursed by trolley operators and passengers, especially during the winter months, when coal deliveries were made with a horse and dump wagon. The new trolley cars designed in the early 1900s had an indentation in their sides to allow coal wagons to pass. (Courtesy of the Bridesburg Historical Society.)

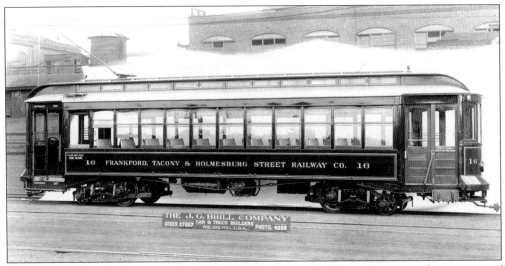

Every trolley manufacturer proudly displayed its production pieces on the streets of Philadelphia, sharing with the world its craftsmanship. The northeast section of Philadelphia enhanced its population with the addition of the Frankford, Tacony & Holmesburg Street Railway Company (originally named the Holmesburg, Tacony & Frankford). Here, the J.G. Brill Company shows one of its sleek, new cars for the line, nicknamed "the Hop, Toad, and Frog Line," in 1914 on Torresdale Avenue. (Courtesy of Andy Maginnis.)

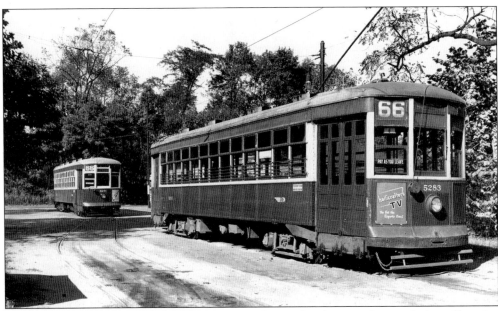

The northeast section of Philadelphia, once sparsely populated, enjoyed an explosion of housing after World War I in the Mayfair section along Frankford Avenue. The news of the expansion of the Market Street Elevated to Frankford made it possible for the Route No. 66 to come on line and travel beyond the city limits to Andalusia, Pennsylvania. (Courtesy of Bob Foley.)

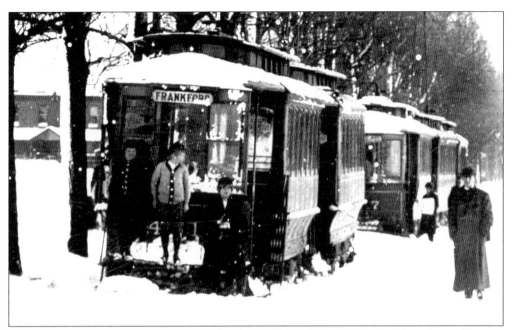

Photographs of a snow-covered Philadelphia during the early 1900s are rare. Here, five trolley cars are stuck in the snow, and the rope fenders have to be dug out so they can push the snow off the tracks. The outlying districts of Frankford in the northeast section of Philadelphia took in larger quantities of snow due to the rural landscape. (Courtesy of the Bridesburg Historical Society.)

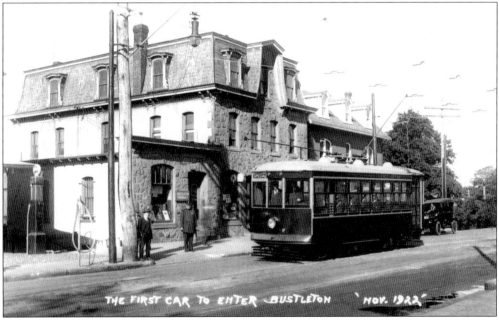

The vast acres of farmland and the village-like settlements in northeast Philadelphia gained notoriety in the 1920s, when a trolley car line from the Frankford section sliced through Castor Avenue and a single-lane highway across the Pennypack Creek to the Bustleton section. The Toonerville (now Birney) trolley, with its double poles, made it possible to serve the area on one track. (Courtesy of the Bridesburg Historical Society.)

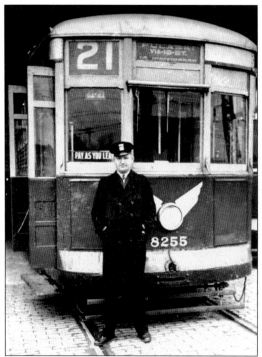

Take me home, Bill! Trolley operator Bill Harvey poses at the Luzerne depot in 1945. The handsome driver took thousands of people directly home and was so proud of his job, his trolley, and his badge, that the wings surrounding the headlights were his own lucky charm. Actually, the 8,000-series trolleys were rebuilt at the Kensington depot with this logo and dubbed the "paint liners." (Courtesy of Dennis Szabo.)

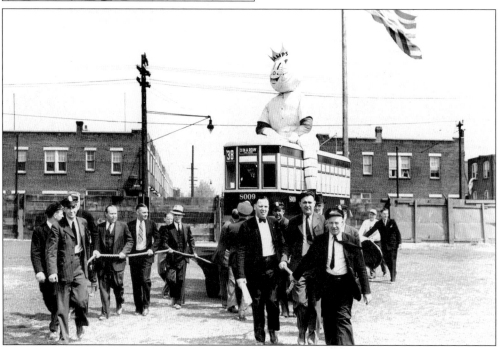

This wild photograph is representative of the friendship that existed among the ranks of the transit employees. The trolley operators from Southern Depot won the transit league baseball series in 1938. The men made a float that looked like a trolley, placing the year and the message "Three in a Row" on the destination window. They then attached ropes and pulled the float in a reversal of roles—men instead of horses. (Courtesy of Dennis Szabo.)

Hospitality in the transit industry is a virtue. The courtesy of operators helping others is legendary throughout Philadelphia. Grown men doing heroic deeds on their daily trips went undocumented for many years. The traveling public always took note of these honorable men and women, however, and rewarded them with presents at the Christmas holiday. Motorman James Markert, with his trolley, is honored driver of the month in August 1967 by the PTC. (Courtesy of Dennis Szabo.)

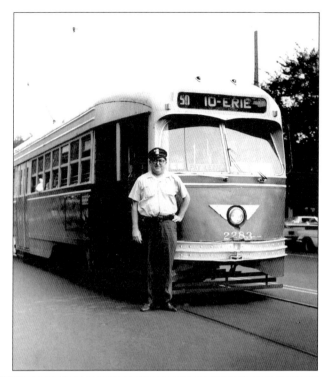

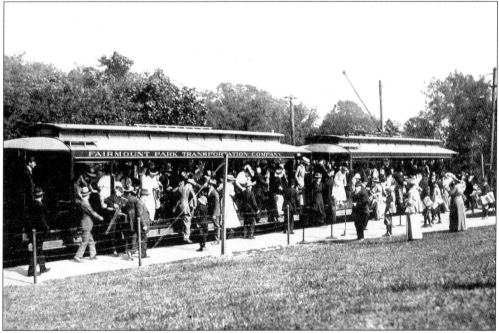

The famous Fairmount Park trolley, a privately owned and operated system, took passengers from Thirty-third and Dauphin Streets in the Strawberry Mansion section of North Philadelphia over its private right-of-way bridge into Fairmount Park and to the Woodside Amusement Park, which opened in 1896. Another boarding terminal located at Forty-fourth Street and Parkside Avenue lured passengers onto its open-air cars. (Courtesy of Malcolm Kates.)

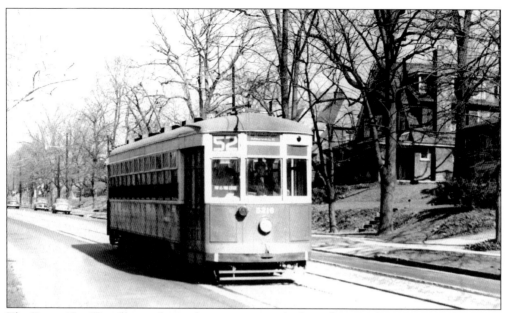

The Route No. 52 trolley took people on a quaint ride through magnificent scenery from Oak Lane, where it dead-ended on Chelten Avenue and Old York Road, to its dead end at Midvale and Ridge Avenue adjacent to the Schuylkill River. The large country houses that once inhabited the rural areas of Germantown and Wissahickon gave the riders on this line a visual treat daily. (Courtesy of Bob Foley.)

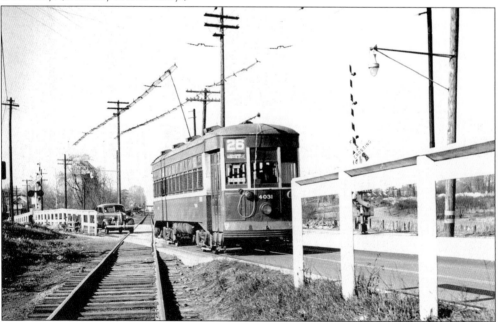

Another rural route within the city encompassed the Germantown-Fox Chase line, which acquired the Route No. 26 designation. The heavy-duty Hog Island cars were used on this line where the trolley had to crisscross other rail lines. Access to the Broad and Olney transportation hub and the Broad Street Subway made this a popular cross-road route, complete with a stop for the famous Fifth and Olney shopping district. (Courtesy of M.E. Borguis.)

The comforts of the modern age in transportation arrived in Philadelphia before the start of World War II. PRT took photographs inside its new PCC cars before reorganizing as the Philadelphia Transportation Company (PTC) in 1938. The padded seats, the cord to alert the operator to stop, and the new fish eye overhead lights made the trip great. (Courtesy of Jeffrey Marinoff.)

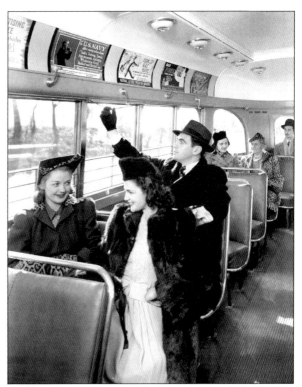

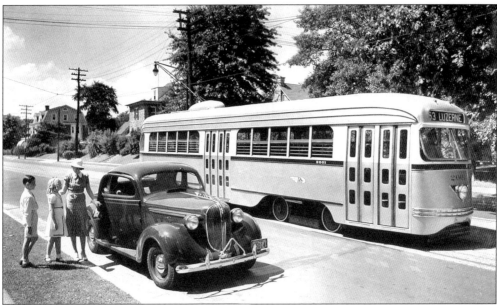

The drive to compete with automobiles in America took place and shape in the 1930s, when the presidents of transit companies in major cities met to discuss strategies to gain more riders after the Depression. The streamlined, comfortable design of Presidential Conference Cars (PCC) won over the Philadelphia public in droves. A combination of aircraft and train technology made them first-class vehicles. They debuted on the Route No. 53 Wayne Avenue line. (Courtesy of Malcolm Kates.)

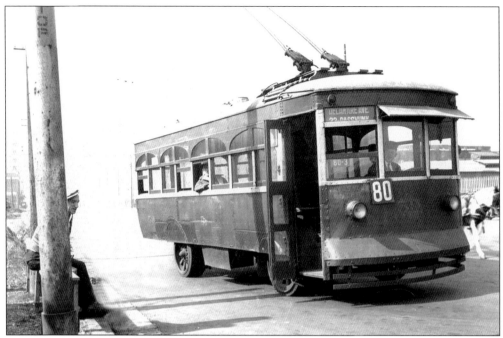

The earliest attempt to electrify a bus that ran on rubber wheels came in the 1920s. The experiment took place on the Route No. 80, which had been a long-running trolley route on Snyder Avenue in South Philadelphia. The look of the vehicle resembled the familiar trolley itself. (Courtesy of Joel Spivak.)

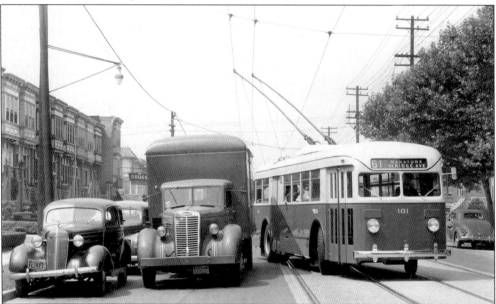

The arrival of the electric bus, better known in Philadelphia as the trackless trolley, provided excellent travel on several lines in the 1940s throughout city. The Route No. 61 ran from Manayunk through Strawberry Mansion on the snaking, diagonal thoroughfare known as Ridge Avenue. The terrific maneuverability around double-parked vehicles on the street proved its worthiness. (Courtesy of Jeffrey Marinoff.)

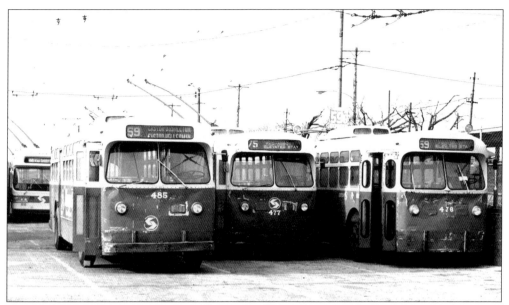

The trackless trolley was a favorite of author Allen Meyers, especially the sense of power it projected and the special noise that came from the motor when the operator placed his foot on the oversized accelerator pedal. Sometimes, the operator allowed passengers to ride from the Frankford transportation terminal down to the Arrott Street loop. When the Meyers family migrated to the Oxford Circle section, they rode on the Route No. 59 up Castor Avenue. Note the new-generation bus on the far left. (Courtesy of Jeffrey Marinoff.)

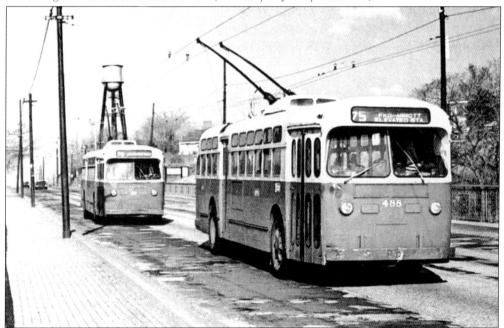

Wide expanses of city streets could be traveled at a high rate of speed by the trackless trolley buses. The Route No. 75 ran along bumpy Wyoming Avenue and connected riders from the Broad Street Subway in Logan with family and friends in Feltonville on its way into Frankford with a connection to the Market-Frankford El. (Courtesy of George Metz.)

A unique gift from Great Britain for America's 200th birthday came in the form of an open trolley car. The historic route of this Blackpool car ran up Fifth Street and down Fourth Street along the Route No. 50 through South Philadelphia and past the Liberty Bell. The Blackpool now operates in San Francisco, California. (Courtesy of Ed Torpey.)

During the 1950s, the subway surface cars to West Philadelphia were routed in separate tunnels on the West Philadelphia side of the Schuylkill River, as the Market Street El went underground to beautify the University City area. The north portal at Thirty-sixth and Market Streets and the south portal at Fortieth Street near Woodland made for a faster ride. The new trolleys built in Japan arrived in Philadelphia during the 1980s. (Courtesy of Robert Wright.)

Six

CARBARNS

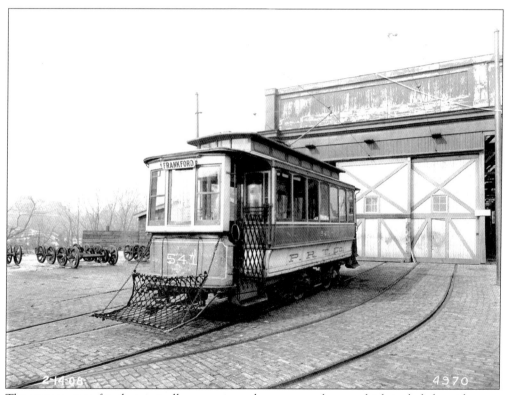

The storage areas for electric trolleys were once known as carbarns, which included a wide array of buildings sometimes occupying whole city blocks and were leftovers from the days of horse-drawn street railways. The sliding doors for many carbarns kept stray animals and children from venturing in to explore the dark caverns. The buildings were expanded in size with the new technology of steel trusses and were built up to 150,000 square feet in size. Throughout the world, the facilities are called by different names. In Great Britain and Europe, they are known as car depots. In Cleveland, Ohio, and in the Midwest, the structures are referred to as car stations. Here in Philadelphia, carbarns are where the trolleys go to sleep. Pictured is the carbarn in Frankford at Bridge and Pratt Streets in the early 1900s. (Courtesy of the Andy Maginnis.)

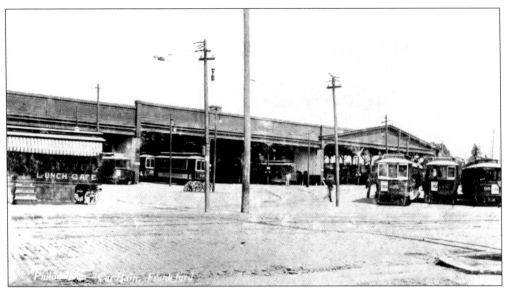

The Frankford carbarn, built in 1904 by PRT, housed many trolleys of its northeast lines. The large facility included smaller buildings converted into repair shops. A lunchroom café sat in the middle of the trolley depot. The nearby open farmland served as a great catalyst in drawing residential development in the once-rural district noted only for its four cemeteries. (Courtesy of Robert Lewis.)

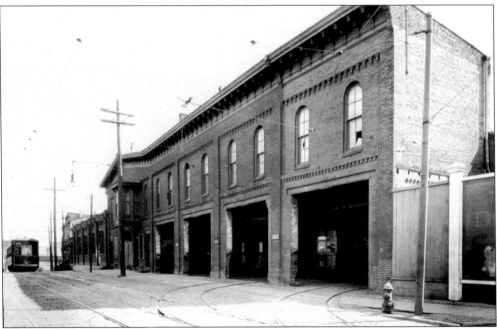

Kensington was loaded with carbarns at one time. Built in 1860, the Amber and Frankford structure served the early horse-drawn railway companies and rivaled the Fifteenth and Cumberland Street carbarn, which was built in 1875. The Amber Street carbarn, converted to hold the trolleys in 1894, remained in daily use until 1913, when the Luzerne Street depot opened. The shop repaired trolleys and had offices above the work areas. (Courtesy of the Dennis Szabo.)

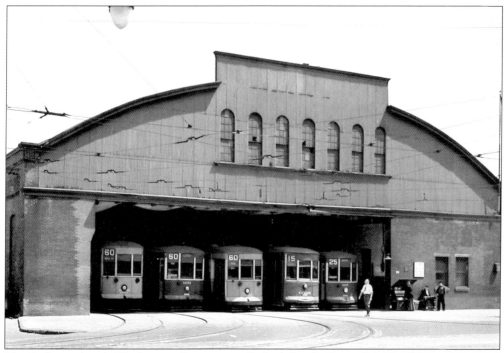

The Richmond and Allegheny carbarn, originally built by the Second & Third Street Passenger Railway Company in 1860, gave way to the largest facility in the 1890s, when the trolley entered the northeast section of Philadelphia. Route Nos. 60, 15, and 25 called this barn home. The facility closed in the late 1950s during the National City Lines bus blitz. (Courtesy of Joe Boscia.)

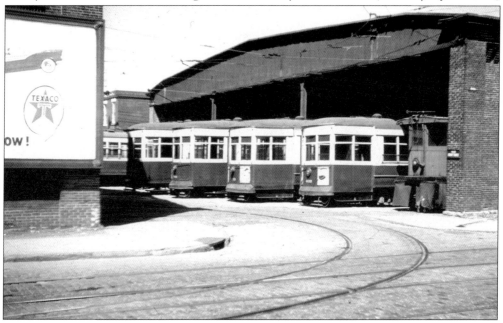

The carbarn construction frenzy continued into the second decade of the 1900s, when the Richmond and Allegheny depot received an additional building. A center entrance off Richmond Street allowed more cars storage space. (Courtesy of Joe Mannix.)

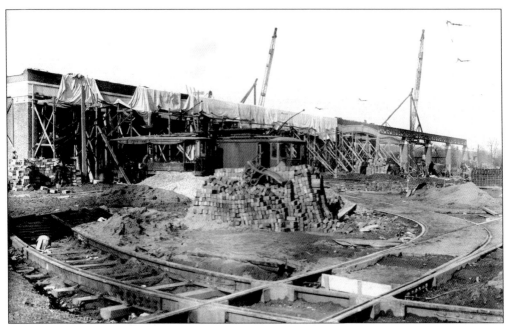

The construction of the Luzerne carbarn at Tenth Street in 1913 served as the gleaming example of modernization in construction and engineering plans. The depot opened to consolidate the smaller facilities in North Philadelphia. At the time of construction, this building was the largest structure built with precast girders. (Courtesy of Joel Spivak.)

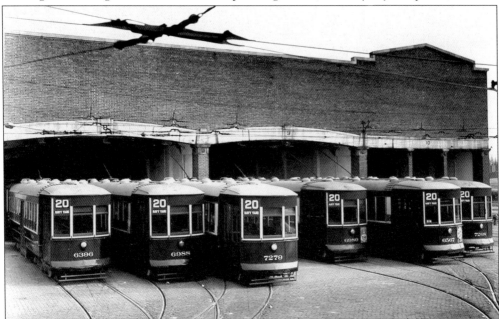

The modern bays of the Tenth and Luzerne Street carbarn housed hundreds of trolleys right off the production lines during the expansion and upgrade of PRT from 1911 to 1914. The unique, three-car bays with track switches were lost in the National City Lines takeover of PTC in 1955 and were converted into a modern garage. The facility closed in 1997 with the opening of the Midvale Avenue bus depot. (Courtesy of Joe Boscia.)

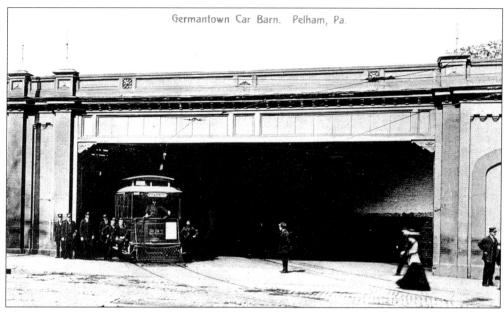

Germantown Car Barn. Pelham, Pa.

The Germantown carbarn at Westview Avenue is depicted on a postcard during the 1890s and is described as Pelham, Pennsylvania. The facility built on the site of the original carbarn is a great example of the new architecture, which included a wide span on a paneled frieze over very tiny brackets. The roof is capped by a classical cornice and is still standing today. (Courtesy of John Nieveen.)

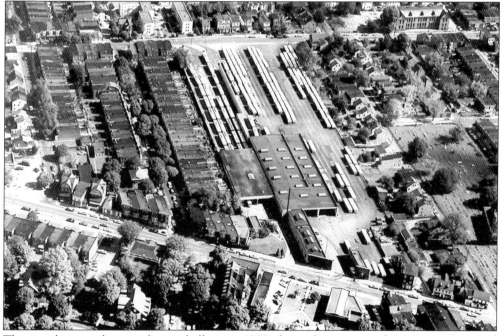

This aerial view, taken in a hot air balloon in 1922, shows the access track on Gorgas Lane and Musgrave Street, which allowed the single-ended cars to enter from the rear of the building. Buses came to this depot in 1955, and then finally during 1992, the depot became inactive. (Courtesy of Joe Boscia.)

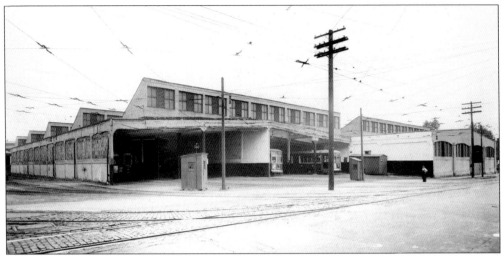

The Twenty-sixth Street and Allegheny Avenue carbarn was built by PRT as a reinforced concrete structure with four bays rising above a shallow gable and a transverse above a saw-toothed roof to bring light into the workspace. Opening in 1907, the carbarn housed 260 full-sized trolleys of the Route No. 60 and No. 48 and the Route No. 61 trackless trolley. The facility, rebuilt in 1974, reflects its prior architectural history. (Courtesy of Bob Foley.)

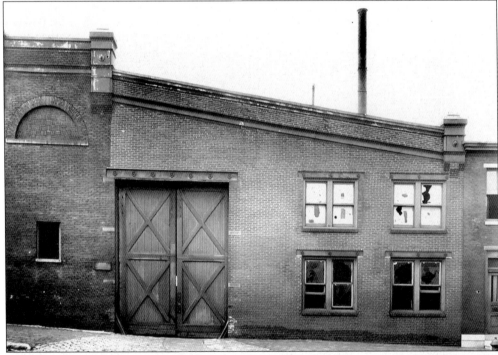

The erection of carbarns is a neighborhood tradition. The transportation buildings blended into the rows of homes in Philadelphia. This rare photograph depicts the carbarn on the corner of Twenty-sixth Street and Fairmount Avenue. The half-moon window to the left of the carbarn doors was reserved for church building and indicated a beginning and an end. The facility was sold in the 1960s and was converted into the headquarters and repair shop of the Yellow Cab Company. (Courtesy of Joel Spivak.)

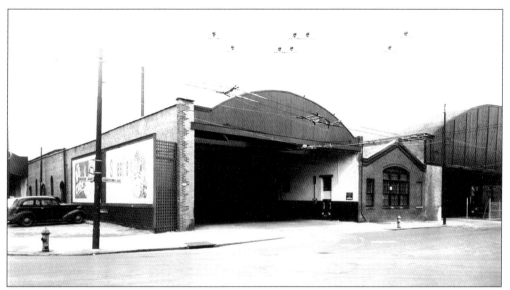

The famous Thirty-second and Ridge Avenue carbarn, when originally built in 1872, consolidated all the Ridge Avenue lines into one company. The barn was enlarged in 1895 by the Union Traction Company to include a power station and offices. Author Allen Meyers, born on nearby Natrona Street, and his mother, Esther Meyers, walked in the middle of the street to avoid being hit by the trolleys leaving this barn in the 1950s. (Courtesy of Joe Boscia.)

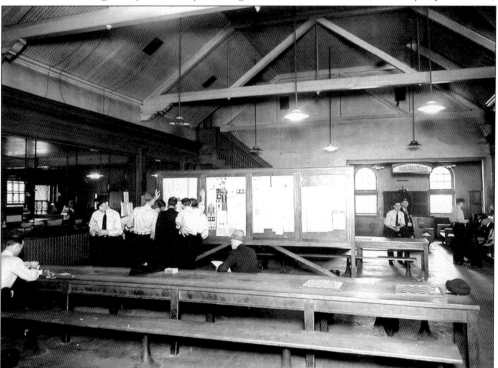

The trainman's room at the Ridge Avenue depot served as a great gathering center for the many employees who rested here on layovers in between runs. The operators played chess, checkers, and pool and went over to Doc Kay's Drug Store for delicious fountain drinks. (Courtesy of Joe Boscia.)

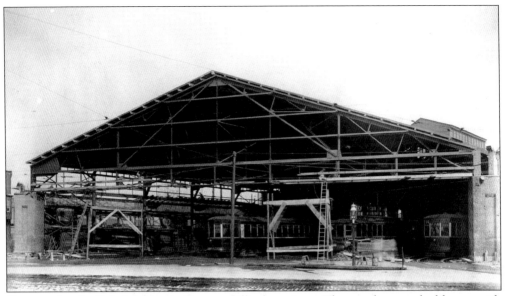

Construction in Philadelphia can be very difficult at times. The weather wreaked havoc with the builders of this carbarn at Belmont and Leidy Avenues in the Parkside section of West Philadelphia. Built in 1875 by the West Philadelphia Passenger Railway for the centennial celebration, the carbarn collapsed early in the second decade of the 20th century and underwent new construction. (Courtesy of Andy Maginnis.)

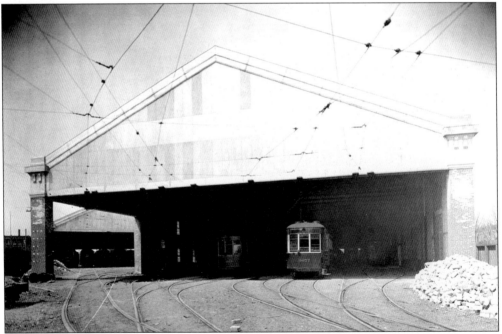

The new carbarn was enlarged by PRT in 1913 and could hold 135 trolleys under one roof. The great gable roof was supported by thin metal trusses in the wall, which were expressed externally as solid brick piers capped with classical brackets and fragments of a cornice. The children at the nearby Leidy School were instructed never to go near the carbarn for safety concerns. (Courtesy of Andy Maginnis.)

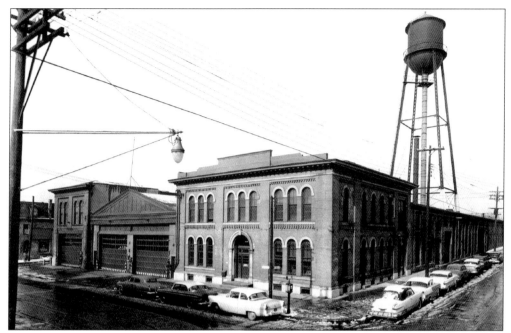

West Philadelphia ran many trolley lines and had a good number of carbarns with ornate designs. The Forty-first Street and Haverford Avenue car house, built by the West Philadelphia Passenger Railway in 1881, became the home of the Philadelphia Traction Company and served as a manufacturing center for 700 cars in the 1890s. (Courtesy of Bob Foley.)

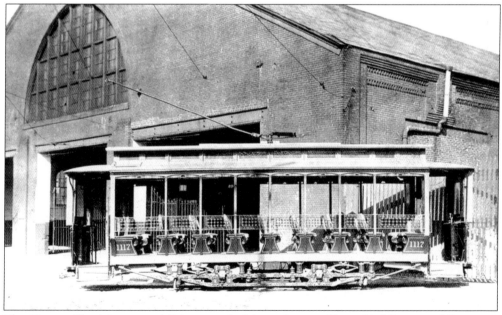

The Hestonville, Mantua and Fairmount had its carbarn at Forty-third Street and Lancaster Avenue with a large section devoted to its stables. The open-air trolley sits in front of the building, which is highlighted by a great, pointed-arch window perched above the center bay and a huge gable roof. PRT later acquired the facility and equipment that had served a large number of passengers when it was built for the centennial in 1875. (Courtesy of Andy Maginnis.)

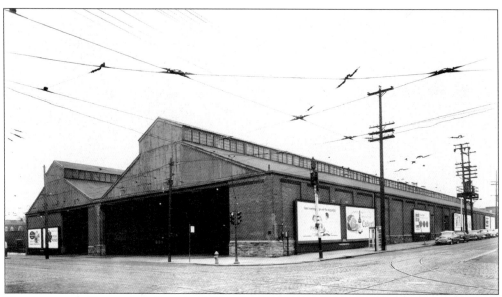

The structure at Forty-ninth Street and Woodland Avenue is the oldest continuously operating property in Philadelphia. Built in 1880, the carbarn replaced a smaller one from 1858. The Philadelphia Traction Company used this site as the main carbarn for its trolleys operating in the 1890s throughout southwest Philadelphia. The carbarn was only blocks from the J.G. Brill Company. The intricate rail configurations can still be seen today in the streets near the carbarn. (Courtesy of Bob Foley.)

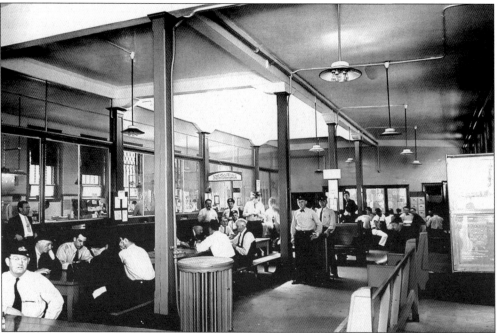

The trainman's room at Forty-ninth Street and Woodland Avenue served as a social hall in the late 1930s for the hundreds of men who operated the Southwest and West Philadelphia trolley. The extremely neat rest area had excellent heat and several large murals of the area in its midst. (Courtesy of Joe Boscia.)

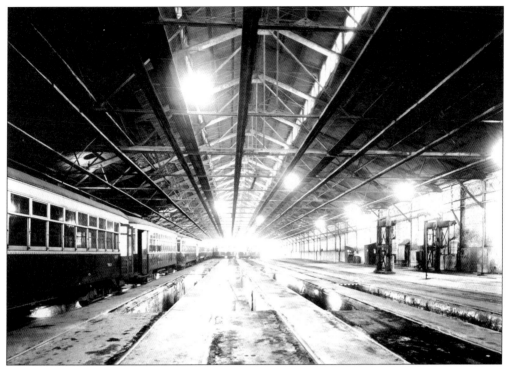

This 1957 photograph offers a rare look into the large cavern of the Forty-ninth Street and Woodland Avenue carbarn, which contained many bays for trolley repairs. This structure spanned an entire city block and was supported by many wooden trusses. (Courtesy of Andy Maginnis.)

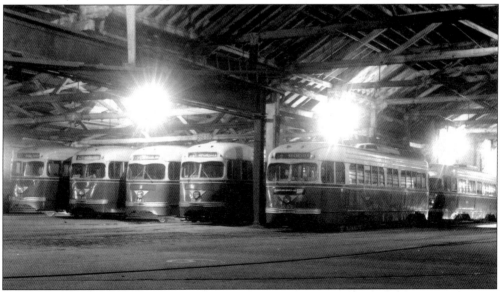

The Forty-ninth Street and Woodland Avenue carbarn's interior included many timbers holding up the large wooden roof. The construction mode used allowed for four trolleys abreast between columns. These streamlined trolleys did not survive the great fire that went to 10 alarms in 1976 at this location. A good portion of Philadelphia's trolley fleet was lost, creating demand for a new building and the next generation of trolleys. (Courtesy of Andy Maginnis.)

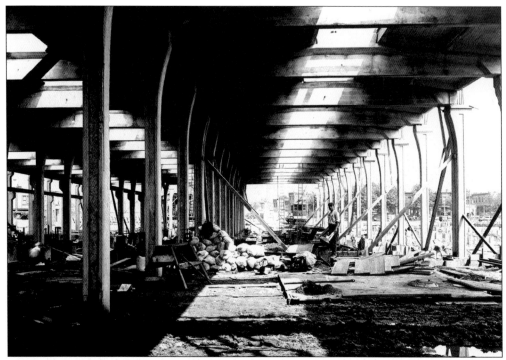

Building the Fifty-eighth and Callowhill Street carbarn in 1913 consisted of hauling beams that were cast at the Tenth and Luzerne multipurpose facility across town via Girard Avenue on special Brill flat cars. The construction took one year to complete. (Courtesy of Andy Maginnis.)

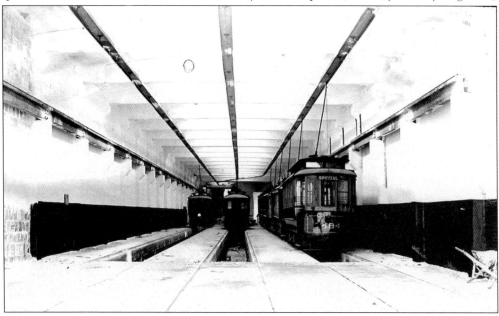

The Callowhill carbarn served as home for the many trolleys that ran above Market Street. Prefabricated beams came as a surprise to West Philadelphia. The interior of this large carbarn was well lit, especially at the Christmas holiday when it opened in 1913. The building was used as a training ground for new mechanics. (Courtesy of Joe Boscia.)

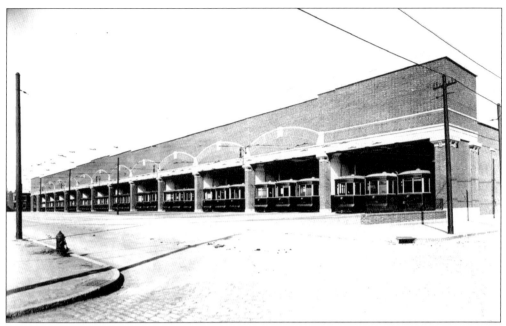

The grand opening of the new carbarn in 1913 christened 33 different trolley cars eager to serve a growing community. The Tenth and Luzerne Street replica, duplicated in West Philadelphia, could hold 330 trolleys under its shelter. The growing number of residents in the community were treated to vehicles bought in this era. (Courtesy of Bob Foley.)

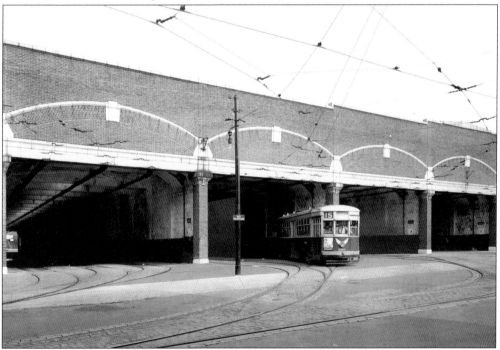

During rush hour, the entire fleet of trolleys abandoned the carbarn at Fifty-eighth and Callowhill Streets for West Philadelphia. Most went downtown via the subway tunnel that alleviated congestion around city hall. (Courtesy of Joe Mannix.)

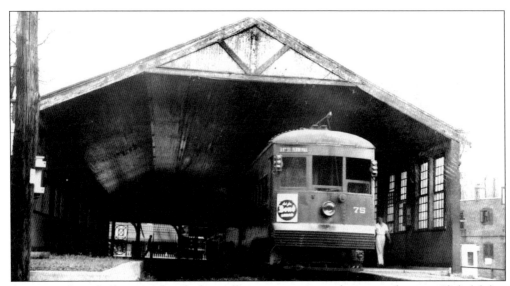

Access to the suburbs arrived with the trolley car routes into the areas adjoining Philadelphia on its western fringe. The Ardmore and Llanerch Passenger Railway opened in the 1890s, and the larger cars sped riders over various terrains rather than the streets of Philadelphia. The large trolley sheds also housed a railway station. (Courtesy of Andy Maginnis.)

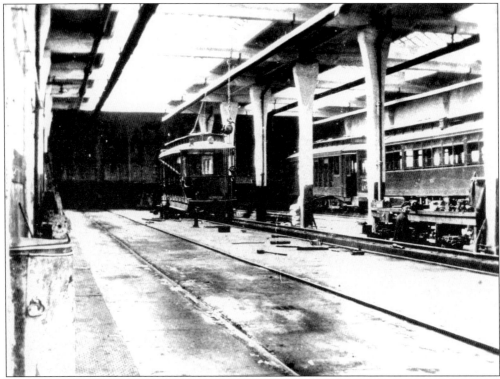

The Lehigh Valley Transit Company serviced Norristown and Erdenheim, just northwest of Philadelphia, with destinations in Allentown. The interurban rides lasted one to one and a half hours. The Fairview carbarn, built in 1914, is reported to have been the first dual-use carbarn made of reinforced concrete. (Courtesy of Andy Maginnis.)

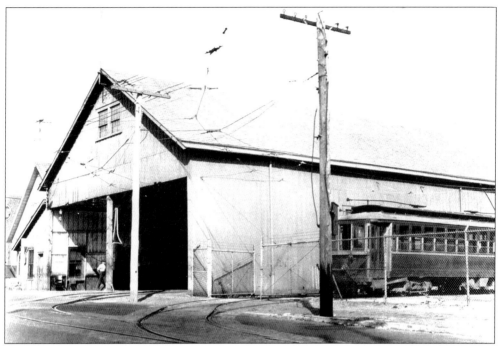

The extension of trolley service west of Angorra (past Sixty-first Street and Baltimore Avenue) outside of Philadelphia provided access to Glenn Riddle, beyond Media (the seat of Delaware County). The Delaware County and Philadelphia Electric Railway operated the line. (Courtesy of Andy Maginnis.)

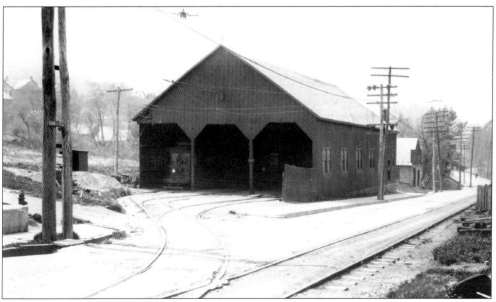

The architecture of rural carbarns often resembled the countryside. The Lehigh Valley Transit Company owned the Slatington carbarn, which looked similar to the many covered bridges in the vicinity. The shed-type carbarn could house a dozen cars in bad weather. (Courtesy of Andy Maginnis.)

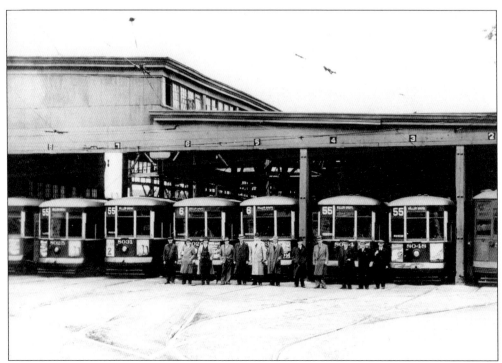

The northern suburbs of Philadelphia were connected by trolleys in the late 1890s, when the Philadelphia Traction Company built the Willow Grove Amusement Park. Rides from Broad and Olney went out Ogontz Avenue on the long trip of 15 miles through mostly open countryside. The wooden trolley carbarn in Willow Grove served the Route No. 55 and Route No. 6, with provisions for the Doylestown line No. 22. (Courtesy of Andy Maginnis.)

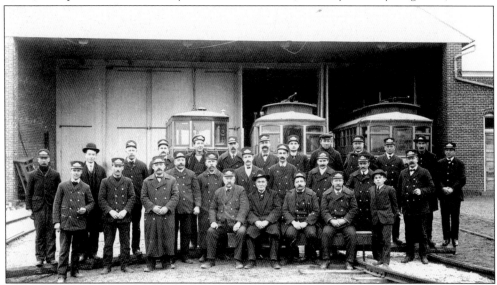

The Souderton carbarn along the Lehigh Valley Transit Company route served the trolleys that connected Allentown to Philadelphia via the Liberty Bell route until the early 1950s. The building caught fire in 1994, and the property was sold to the Clemens Food Market. (Courtesy of Andy Maginnis.)

Seven
TRANSPORTATION HUBS

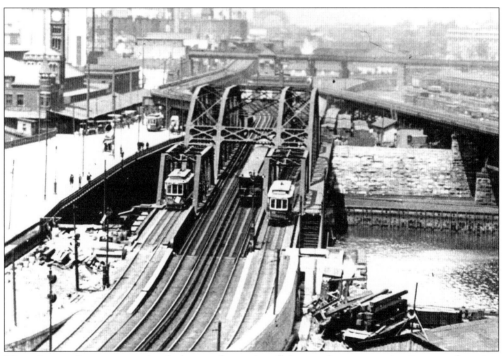

The advent of a transportation hub served to unite all forms of transportation into one location where riders could make transfers to other lines. The termination of one line and the beginning of another line often allowed great throngs of people access to various sections via a short walk across a common property or transportation center. The urban hubs took in various lines that radiated out in different directions, and the interurban hubs allowed passage into Philadelphia from places more than 30 to 40 miles away. This rare photograph, taken from a warehouse on the east side of the Schuylkill River in the second decade of the 20th century, gives a panoramic view of both a trolley and the Market Street El as its snakes its way into West Philadelphia at Thirtieth and Market Streets. (Courtesy of Andy Maginnis.)

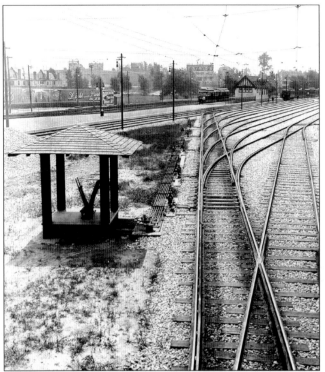

An important job in the trolley car industry was that of a switchman in a large facility where vehicles came in on track and needed to be switched to the correct loading track. The arrival of many trolleys at the Willow Grove Amusement Park in the 1900s necessitated this switchman's shed and equipment. (Courtesy of the Free Library of Philadelphia.)

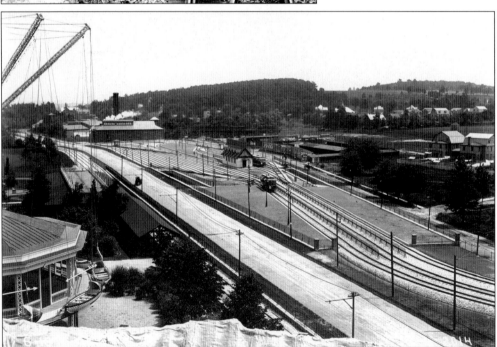

The paved superhighway of the modern era can be seen in the countryside beyond the Willow Grove terminal. The anticipation of automobile traffic with the trolley car frenzy in the summertime gave city planners a big chore in this community. The airship ride at the amusement park is to the left. (Courtesy of Andy Maginnis.)

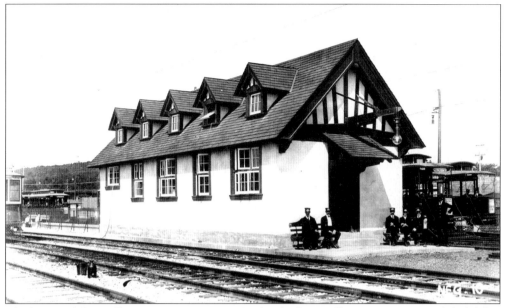

The layout of the Willow Grove Amusement Park relied on trolleys originating in Philadelphia and making the journey out to the countryside. The architecture of the trainman's rest facility is styled after the Great Britain countryside, with a flair for the Tudor influence. The many tracks allowed quick loading for the trip back to the city. (Courtesy of Andy Maginnis.)

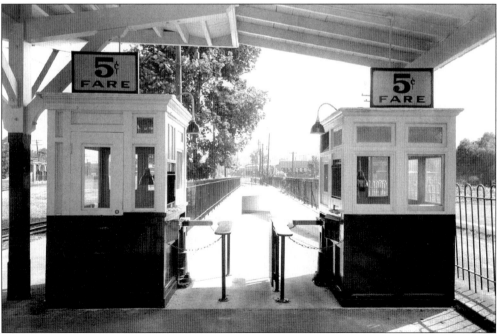

The orderly entrance to the waiting trolley took hold early in the second decade of the 20th century with the addition of a turnstile system for fare collection. This 1944 photograph shows the importance of order and rider safety, with fencing to prevent trolley accidents. The lines back to Philadelphia were usually long in the summer after the fireworks display held every Saturday evening. (Courtesy of Andy Maginnis.)

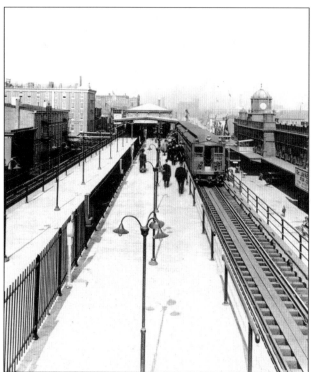

The Delaware Avenue extension of the Market Street El allowed great access to the various Delaware River ferries. The service lasted for 30 years and ran to South Street with connections to Kaighn Avenue in Camden, New Jersey, via a ferry. The opening of the Ben Franklin Bridge in 1926 led to a decline in ferry revenue and the closure of the Delaware Avenue extension in 1939. (Courtesy of Andy Maginnis.)

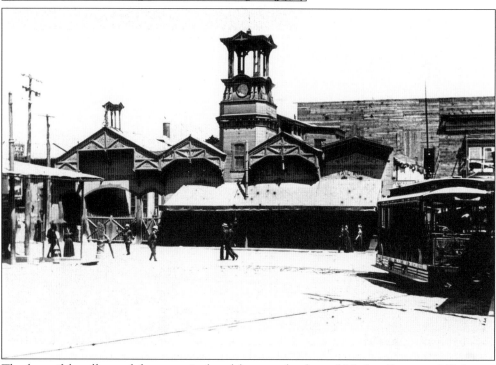

The beautiful trolley and ferry terminal and loop at the foot of Market Street and Delaware Avenue opened for business in 1890. The structure, with its many roofs, served as a landmark for many decades for newly arriving immigrants on boats from Europe. (Courtesy of Robert Lewis.)

The Delaware River Bridge (now the Ben Franklin) opened in 1926 north of Market Street as a tribute to modern engineering. The suspension bridge connecting Philadelphia to Camden, New Jersey, had many transportation modes incorporated into its design. An outer lane that was devoted to trolleys with elevator access from the street level never made it into use. Instead, an elevated subway, inaugurated by motorman Charles McCarthy, opened in 1932 and connected the cities. (Courtesy of Bob Foley.)

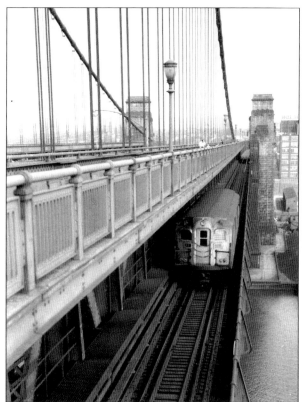

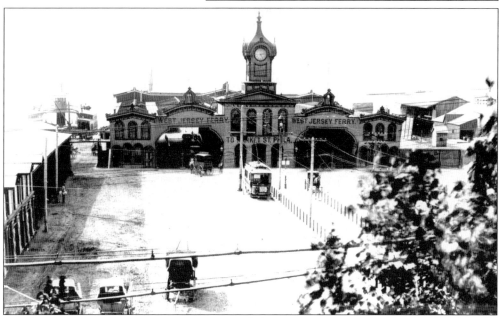

Another ornate transportation center awaited ferry passengers on the Camden side of the Delaware River. Access to trolleys serving the region and to trains bound for Atlantic City made the West Jersey Railroad terminal a busy hub in the summertime during the late 19th century. (Courtesy of Robert Lewis.)

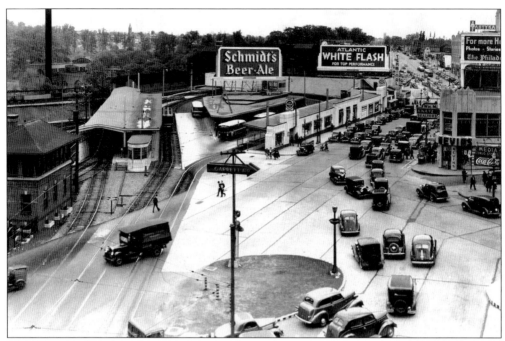

The Sixty-ninth and Market Street terminal served as a transportation hub dating back to the early 1900s. The end of the Philadelphia Market Street El led to the creation of a regional transportation center with trolley and bus lines to the western suburbs. Automobile traffic increased the congestion as well. (Courtesy of Bob Foley.)

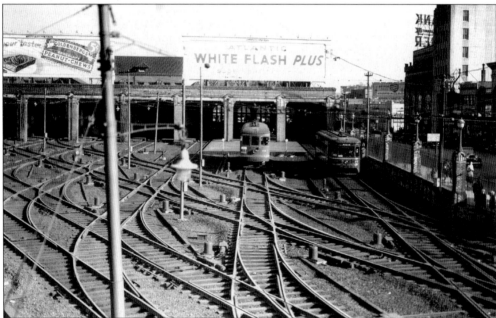

This maze of tracks, controlled by a watchtower and several men who switched the heavy-duty interurban trolleys, served the western suburbs around Philadelphia. The different portals had their own trolleys to Ardmore, West Chester, Sharon Hill, Media, and Norristown. (Photograph by D. Bell.)

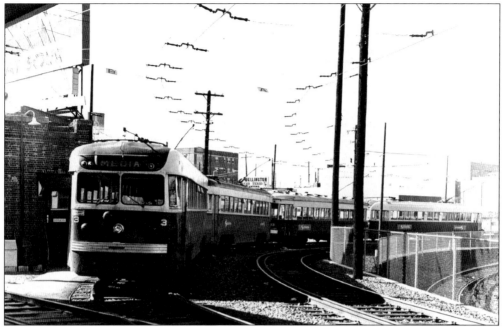

The fleet of interurban trolleys served the Red Arrow Transit Company and the thousands of people who preferred to live in the suburbs. Passengers enjoyed easy access to downtown Philadelphia via the Market Street El and a speedy 25-minute ride downtown. The hub at Sixty-ninth Street filled with screeching steel wheels at rush hour. (Courtesy of Andy Maginnis.)

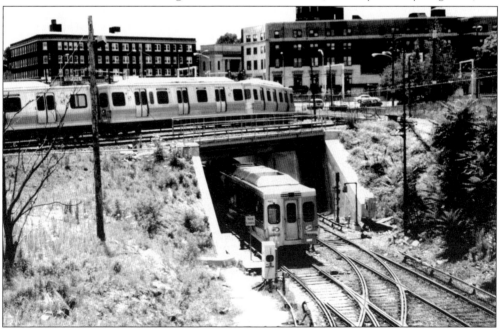

Seen in this rare view, the third-generation El trains built by the Abtranz Company went into service at the Sixty-ninth Street terminal. The trains with noisy air fans, nicknamed "the almond joy cars," were replaced with quiet air-conditioned cars in the late 1990s. (Courtesy of Robert Wright.)

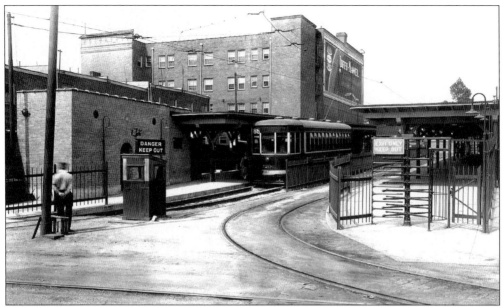

Transportation hubs served the riding public with multiple connections to outlying areas at the end of strategic locations throughout Philadelphia. The Broad and Olney hub brought trolleys in from the northern suburbs, with connections to all directions above the once-rural location made famous by the relocation of the Jewish Hospital from West Philadelphia in the 1870s. On the right, note the metal turnstile configuration for exiting the busy platform with safety in mind. (Courtesy of Dennis Szabo.)

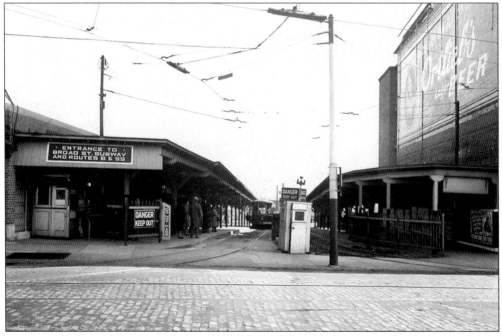

The trolley platform's large passenger shelter allowed a multitude of people to exit the North Broad Street subway and remain dry from any inclement weather. The hub served the Route Nos. 6, 55, 65, and 26 trolley lines with frequent service all day and night. (Courtesy of Joe Boscia.)

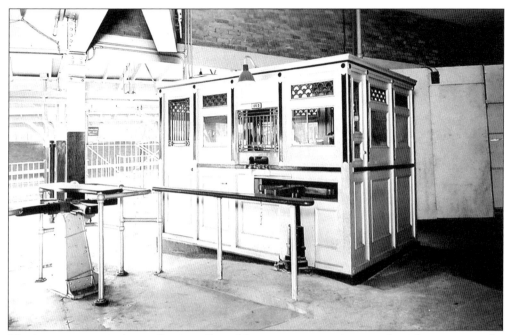

The improvement in fare collection allowed for greater convenience and quicker access to the trolleys. The riding public could pay the 5¢ fare at the cashier booth to the right or zip through the automatic turnstile for the deposit of a token at Broad and Olney. (Courtesy of Joe Boscia.)

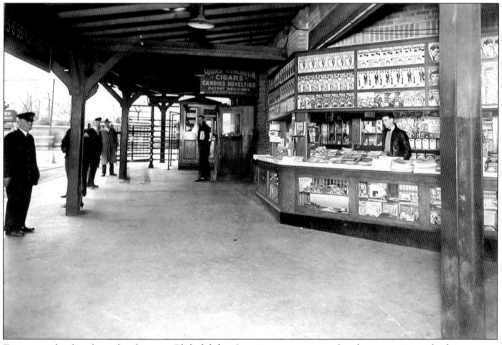

Everyone had to buy the famous *Philadelphia Inquirer* newspaper for the morning ride downtown on the Broad Street subway. On the return trip, riders could purchase the *Philadelphia Evening Bulletin* for a leisurely read on the trolley car to their home destination from this popular newsstand at Broad and Olney. (Courtesy of Joe Boscia.)

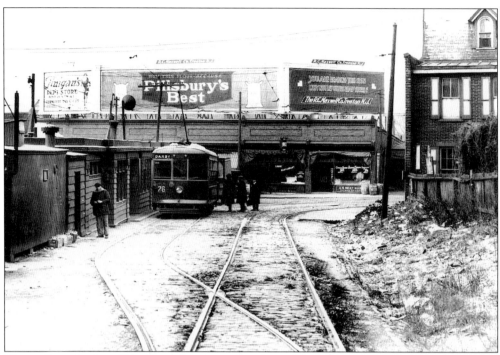

The trolley ride along Woodland Avenue in Southwest Philadelphia terminated in the town of Darby, just outside of the city limits. Connections to Chester, Lansdowne, and Springfield in Delaware County were made via the southwest hub at Ninth and Main Streets in Darby. (Courtesy of Dennis Szabo.)

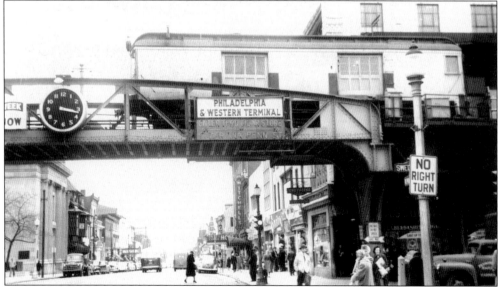

Travel from the Sixty-ninth and Market Street terminal on the Philadelphia and Western Railway took only minutes to go to Norristown. The single-car interurban trolley traveled at speeds of more than 60 miles an hour on its private right-of-way, shuttling people to the seat of Montgomery County in Norristown and dropping them off at Main and Swede Streets. (Courtesy of the Robert T. York Collection.)

Eight
FROM CITY TO CITY

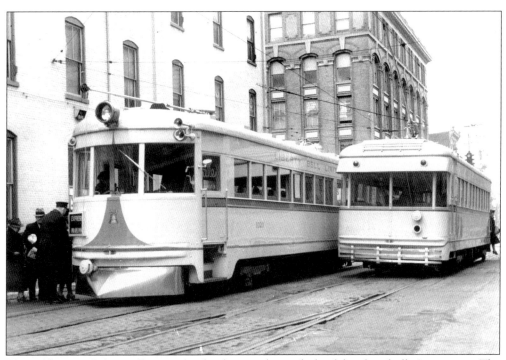

The addition of the trolley to the landscape changed the lifestyle of all Americans. The Philadelphia region served as a model in the development of interurban transfer from one city to another. Lines radiated out more than 60 miles from the wharves of the immigrant stations that brought thousands of new people to the country from the 1890s to 1920s. Investors provided funds for trolley lines running through rural areas in search of urban centers of settlement. The attraction of scenery and the daily commute for work via a single connection added to this frenzy of development. Two interurban trolleys pass each other at Eighth and Hamilton Streets in Allentown, Pennsylvania. Both owned and operated by the Lehigh Valley Transit Company, they traveled to the northwest suburbs of Philadelphia. (Courtesy of Andy Maginnis.)

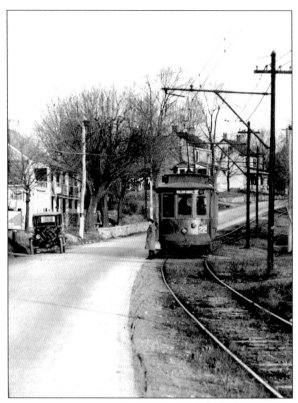

The interurban transportation lines could stop in small towns and villages more frequently than fully-loaded passenger trains. This 1920s photograph shows the rural nature of the trolley line through the town of Edison, Pennsylvania, on the Route No. 22 line from Willow Grove to Doylestown. (Courtesy of Bob Foley.)

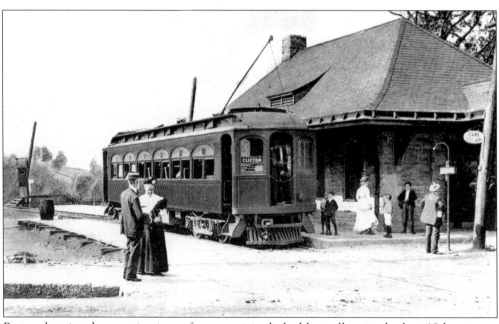

Postcards painted romantic views of communities linked by trolleys in the late 19th century. The Philadelphia and West Chester Railway Company provided service along the West Chester Pike in the western suburbs from Upper Darby to the seat of Chester County, before the arrival of the Market Street terminal at Sixty-ninth Street. (Courtesy of Bob Foley.)

Trolley cars provided an inexpensive way to travel from city to city. The entrance in 1926 of the large interurbans, as they were called, provided a step up in travel from West Philadelphia to West Chester, which previously had only horsecar lines dating back to the 1850s. (Courtesy of Jeff Marinoff.)

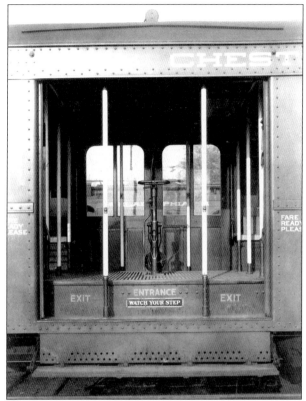

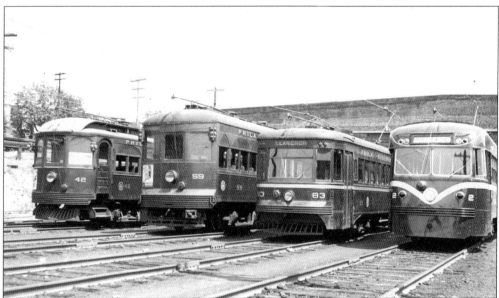

The interurbans allowed designers to create various front-end details. Each line that operated out of the Llanerch carbarn ran to different locales. Pictured, from left to right, are No. 42 (Jewett, 1914), No. 59 (center door car, 1918), No. 83 (Brill, 1932), and No. 2 (Brilliner, 1941). The passengers knew and loved their particular trolleys until 1974, when the Llanerch carbarn closed. (Courtesy of Andy Maginnis.)

An example of the rural nature of the trolley routes outside the city is seen in this 1909 photograph of the Hatboro-Doylestown line. The view is looking northward from the intersection of Blair Mill and Easton Roads toward Doylestown. Dirt roads were plentiful in those days. (Courtesy of Bob Foley.)

Waiting in the outside shelters for an intercity trolley car to come according to the schedule was an experience in itself. The printed schedules did not always allow for delays due to debris overlaying the tracks or bad weather. The Philadelphia and Southwestern Railway Company opened in 1898 and connected South Philadelphia with Wanamaker Avenue in Essington. (Courtesy of the Robert T. York Collection.)

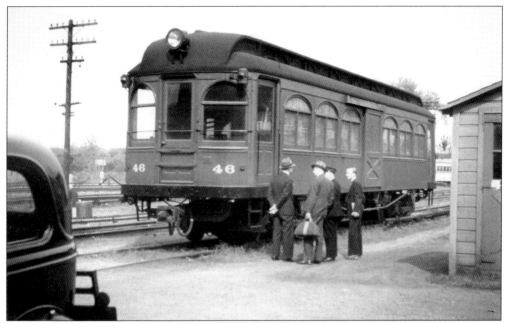

The scale of the trolley cars to the men standing at the Seventy-second Street yard is clearly seen in this early 1939 photograph of the Philadelphia and Western interurban to Norristown. The large truck chassis allowed the interurban to service high platform stations with ease. It took 52 minutes to arrive in Norristown. (Courtesy of Dennis Szabo.)

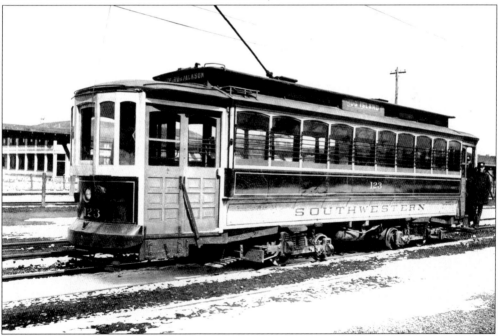

The upgrade on the Southwestern line from Third Street and Moyamensing Avenue in South Philadelphia to the Hog Island Shipyard allowed thousands of workers to ride in safety to work every day. The cars were bought from the Third Avenue Railway Company in New York City late in the second decade of the 20th century. (Courtesy of Andy Maginnis.)

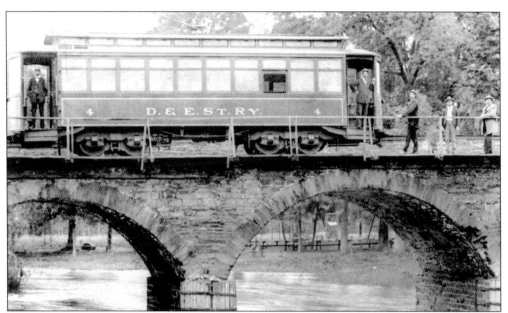

The interurban railway companies built their entire lines with investors' funds. The right-of-way gave ample room for laying tracks but provided no access over public structures such as bridges. The construction of the railway infrastructure was absorbed into the capital budgets of these companies. The above photograph shows a trolley of the Doylestown-Easton Railway Company on a bridge over the Tohickon Creek early in the second decade of the 20th century. (Courtesy of Bob Foley.)

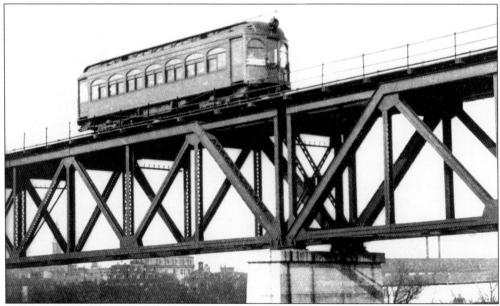

What a ride for passengers traveling on the Philadelphia and Western Railway from Sixty-ninth Street to Norristown over the Schuylkill River! The technology of concrete pilings in riverbeds goes back to the 1866 construction feat and accomplishment of the Brooklyn Bridge in New York. The steel girders provided great stability due to crosswinds and the sheer weight of the interurban cars themselves. (Courtesy of Bob Foley.)

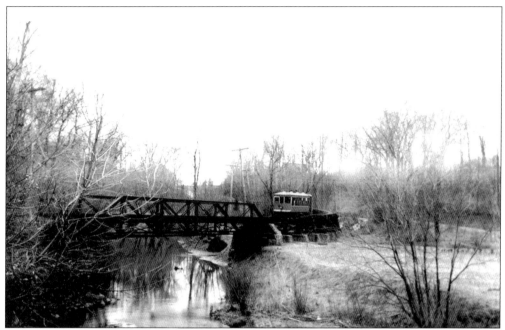

The pristine views of nature on these rural trolley lines were breathtaking, not to mention the ride across some structures. The wooden timbers in this construction creaked and shook when the trolley traveled over the Swarthmore trestle. Breakdowns in the wilderness or other mishaps were unthinkable for the passengers and motormen alike. (Courtesy of Bob Foley.)

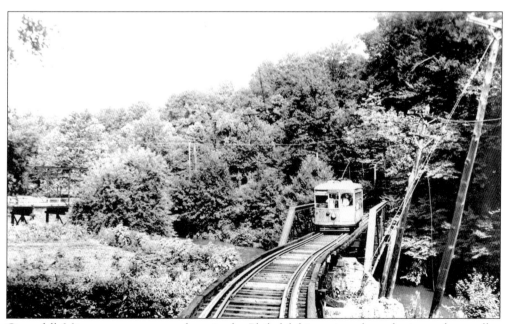

Great fall foliage was seen everywhere in the Philadelphia region along the interurban trolley routes. The Birney cars were reliable vehicles that were the backbone of the short runs from Media to Folsom. (Courtesy of Andy Maginnis.)

WAYSIDE SCENES

along the

Philadelphia & Easton Electric Railway

Finest Trolley Ride in Pennsylvania

Where the meadow daisies grow. Where the rippled rivers flow.

Promotion and advertisement paraphernalia of specific interurban lines invited citizens to join the fun of riding a trolley car through the wilderness. Booklets were published by the railways to entice new riders to take a leisurely ride into the countryside. (Courtesy of the Old York Road Historic Society.)

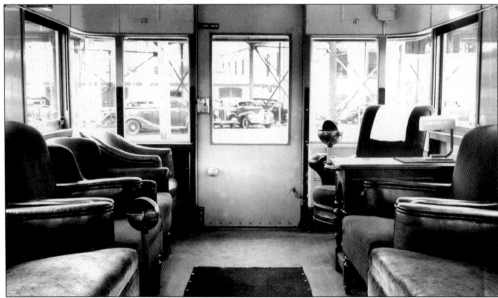

Interurban passengers were treated with respect and dignity. The hard, wooden benches of local runs were upgraded to padded, upholstered chairs. The Liberty Bell route from Allentown to Philadelphia operated by the Lehigh Valley Transit Company lavished customers with comfortable furniture to give them a sense of home. Smokers were even welcomed. (Courtesy of Andy Maginnis.)

Nine
THE HEROES OF HISTORY

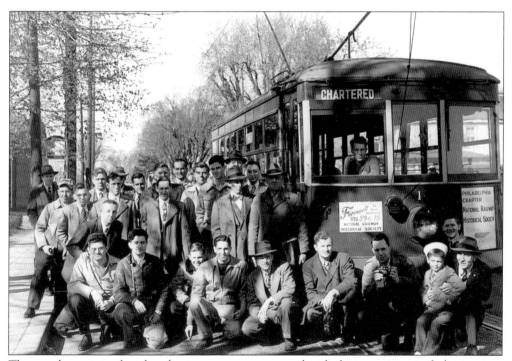

The people contained in this chapter are men concerned with the preservation of a bygone era. Without these men, this book and other pieces of transportation history would be lost forever. Courageous men went on scavenger hunts for old photographs discarded by institutions and rescued heavy turn-of-the-century glass-plate negatives while others took photographs of trolley cars on their bicycles or even took their wives on daylong trips to salvage pieces of Americana here in Philadelphia. This handful of history buffs is only a fraction of the people who have created trolley associations for the preservation of the lifestyle. The closure of trolley lines gave way to a fan trip in 1947 on the old Bustleton line, sponsored by the National Railway Historical Society. (Courtesy of Dennis Szabo.)

Joe Alfonsi, born on August 14, 1914, poses with his favorite trolley car in the background. He worked for the old PRT and PTC from 1935 to 1978. An avid model-railroader, he started an association in Tansboro, New Jersey, in 1958 to collect and restore old Philadelphia trolley cars. These vehicles are now in operation at the trolley museum in Scranton, Pennsylvania. (Courtesy of Dennis Szabo.)

When Harold Cox grew up in Lynchburg, Virginia, the trolley ran right outside his front door in the 1940s. The Brillmaster cars ran on a line in his neighborhood, and an ancient, four-wheel, deck-roof car ran on a shuttle line only one block away. The secret to Cox's work, especially on his excellent trolley route book, came from his secret access to the PTC vault archives. (Photograph by Joel Spivak.)

Born in 1919, Joe Mannix loved to take photographs of the nearside trolleys in the late 1930s. For many years, he and his wife went on trolley-car dates and lived in the Cresentville section of northeast Philadelphia, only a short walk from the Route No. 50 trolley on Rising Sun Avenue. Mannix boasted that he did not need an automobile to travel the city. (Courtesy of Joe Mannix.)

A natural trolley operator, Jeffrey Marinoff is behind the controls of a transit vehicle. That look of belonging is partially due to his actual involvement in the transportation field in Atlantic City. From one coast to the other, Marinoff rode many urban trolley lines as a guest, but his favorite is the trackless trolley that is still in service today. (Courtesy of Jeffrey Marinoff.)

Growing up during the 1950s in Pittsburgh, Pennsylvania, Joe Boscia was allowed a certain sense of independence when it came to public transportation, since his parents did not have a car. He looked forward to riding the 1,700-series PCC trolley cars, in which he could sit alone. Today, Boscia is a transit consultant and collector, and he prizes his old Philadelphia cable-car gripman badge. (Photograph by Joel Spivak.)

John Nieveen had it made growing up in Lansdowne, where he could access the trolleys, interurbans, and the Market Street El at Sixty-ninth Street. With a sense of nostalgia for the older forms of transportation, he started to photograph them and became an instant historian, only he did not know it at the time. Nieveen owns a Russian model of the Red Arrow trolley car manufactured by the St. Louis Company in the fancy paint scheme. (Photograph by Joel Spivak.)

Dennis Szabo spent his childhood in Feltonville and Burholme near the Route No. 50 and Route No. 26 trolleys in the 1950s. His friend Jim Markert related the story of a new motorwoman on the Route No. 26 trolley during World War II. She did not see her leader and made a wrong turn on Chelten Avenue, thus becoming the Route No. 52 all the way to Midvale Avenue. Szabo collects O-scale conventional streetcars. (Photograph by Joel Spivak.)

Shown are the well-known Andy Maginnis (left) and Bob Foley. Maginnis grew up in the Germantown section of Philadelphia, and Foley grew up in the Rittenhouse Square area west of South Broad Street. Maginnis, an avid collector of Lehigh Valley Transit memorabilia, is proud to own a controller from the Liberty Bell route to Allentown. Foley recalls the Shore Fast line as his favorite childhood trolley ride. (Photograph by Joel Spivak.)

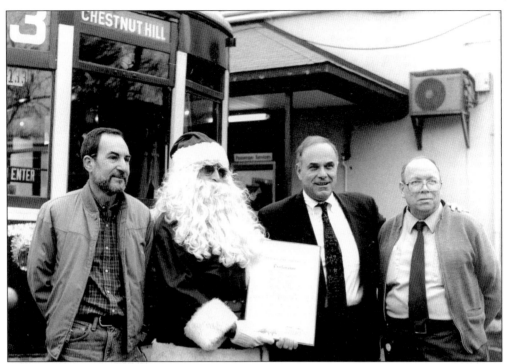

What would Christmastime be like without Mayor Ed Rendell and his good trolley fans? From left to right are SEPTA management analyst Ed Springer, Joel Spivak as Santa, Mayor Rendell, and Richard Vible. The group celebrated the trolley's birthday with a city proclamation in front of a 1926 Peter Witt, known as a nearside car, in Chestnut Hill during the 1990s. (Courtesy of Joel Spivak.)

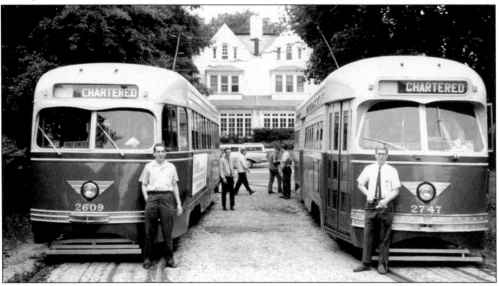

Trolley fans tend to grow up, or do they? Ernie Mozer, left, experienced his first fan trip in the late 1940s and now conducts a tour himself. The man on the right is John Engleman at the Route No. 53 loop in Northwest Philadelphia at Wayne Avenue and Carpenter Lane. The history is kept alive by continuous chartered fan trips. (Courtesy of Tony Dawson.)

Ten

RELICS

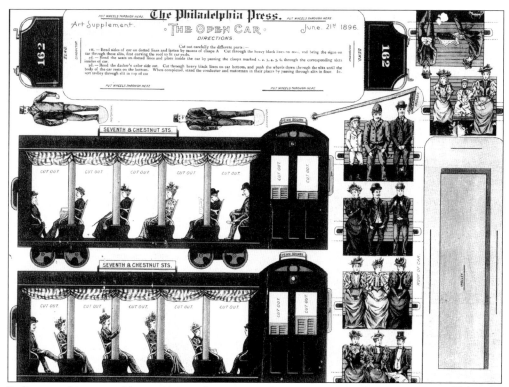

Relics are objects used by previous cultures to explain a certain civilization or way of life. The evolution of the trolley and its effect on residents of Philadelphia is a century-old tradition. The prized collections of these items make for more than just a plain memorabilia display. The men and women who collect these artifacts have a real love for Philadelphia's transit history, and the items themselves often tell a great story of the past. The interpretations of these objects are reflected in the opinions held primarily by the collectors themselves. Cutouts are always fun to make, especially if they represent something familiar. This trolley set came as a supplement to the *Philadelphia Record* Sunday edition on June 21, 1896. (Courtesy of Joel Spivak.)

Originally, the streetcar carriages operating in Philadelphia looked like houses on wheels. Philadelphians' affinity for home life quickly blended into the daily culture; the logos for many railway companies reflected this bond. The West Philadelphia Passenger Railway Company's checks were printed on cream-colored stock. (Courtesy of Joel Spivak.)

Stock sold by the private railway companies made it possible for capital to be laid out for the infrastructure of the trolley system in Philadelphia. The shares were great investments and carried a certain amount of risk. The Frankford-Southwark line displayed the mythical symbol for speed—Mercury with wings—on its stock issues. (Courtesy of Joel Spivak.)

Friendly competition kept the thousands of transit employees occupied during the spring and summer with baseball leagues. Athletic programs within PRT and PTC made it possible for all employees to show off their skills. The famed company picnic of 1920 awarded real gold metals. The one shown above was given to E.L. Billine for the 220-yard relay. (Courtesy of Joel Spivak.)

PLAY BALL

SEASON OPENS MAY FIFTH
WITH TWO LEAGUES IN THE FIELD

MAKE THIS A RECORD-BREAKING YEAR

OFFICIAL SCHEDULES—CHAMPIONSHIP SEASON 1925

LEAGUE "A"

MAY						AUGUST		
6 Richmond	vs. Willow Grove	18 Germantown	vs. Willow Grove		5 Allegheny	vs. Luzerne		
7 Luzerne	" Germantown	19 Luzerne	" Ridge		6 Germantown	" Richmond		
8 Allegheny	" Ridge	24 Allegheny	" Germantown		7 Ridge	" Willow Grove		
13 Allegheny	" Richmond	25 Willow Grove	" Luzerne		12 Willow Grove	" Allegheny		
14 Willow Grove	" Germantown	26 Ridge	" Richmond		13 Richmond	" Luzerne		
		JULY			14 Ridge	" Germantown		

The spirit of the games gave the men a great sense of pride playing in the western or eastern league, and the loyalty to a certain depot seemed almost invincible until the men were traded (transferred to another facility). The split shifts that accented the transit culture gave way to a solid friendship club. (Courtesy of Tom O'Donald.)

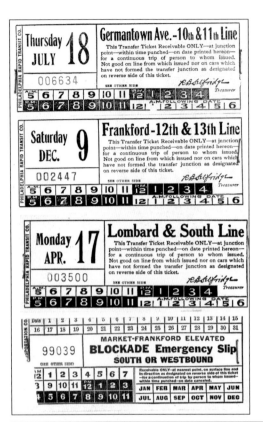

The introduction of the paper coupon, or transit transfer, allowed passage from one line to another free of charge and commenced with the establishment of the Philadelphia Rapid Transit Company in 1902. During World War II, the concept of a free ride took on new meaning for students at the old Northeast High School at Eighth Street and Lehigh Avenue in North Philadelphia. They gave their transfers to waiting friends at Germantown Avenue for passage on the Route No. 23. (Courtesy of Joel Spivak.)

Railway companies provided many gimmicks to get more riders. PRT sold tickets on its trolley routes good for admission to the Willow Grove Amusement Park and made it convenient for all city residents to ride on express trolleys from Fourth and Pine Streets out to the countryside. (Courtesy of Joel Spivak.)

Even the common, brass-sash pulldowns on trolleys were emboldened with the railway insignias. The relic from car No. 475, which ran to Wilmington, Delaware, is being restored by Preservation Pottstown. (Courtesy of Joel Spivak.)

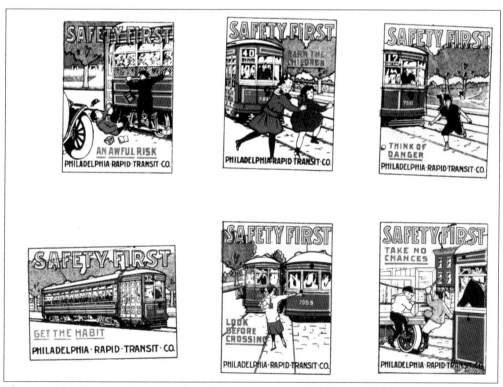

The rope fenders on the original trolleys were succeeded by track fenders. The result in pedestrian accidents led PRT to issue safety stamps for collection as a reminder to children and adults alike in the second decade of the 20th century. (Courtesy of Joel Spivak.)

On the top left is a Philadelphia Rapid Transit Company motorman badge from 1903 to 1914, and on the top right is a Philadelphia Traction Company flagman badge. On the bottom left is a PTC badge from 1938 to 1968, and on the bottom right is a PRT badge from 1914 to 1968.

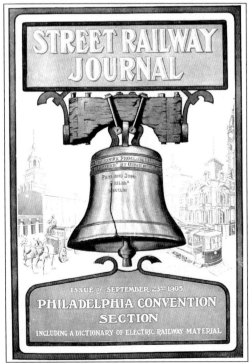

At the 1905 national street railway convention held in Philadelphia, the attendees were given a special edition of the *Street Railway Journal*, a collector's dream. The artifact, a hard-bound volume, included a dictionary and advertisements for many companies that contributed to the industry. (Courtesy of Bob Skaler.)

Motormen were issued standard uniforms to wear on the job as work clothes during the creation of PRT in the early 1900s. The men had to look and dress the part of a professional and were expected to act courteous and polite at all times. (Courtesy of Joel Spivak.)

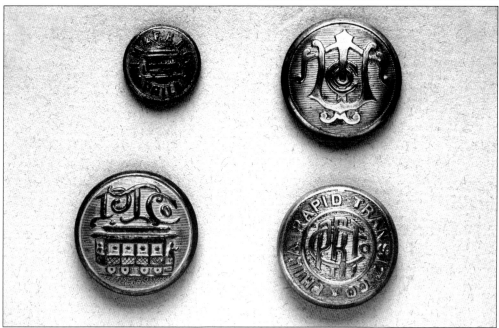

The dress code of the Society of Professional Motormen and Conductors included neat buttons attached to company-issued uniforms. The employees displayed the buttons with pride. On the top left is a Hestonville, Mantua and Fairmount button, and on the top right is a Union Traction Company button. On the bottom left is a Philadelphia Traction Company button, and on the bottom right is a Philadelphia Rapid Transit Company button. (Courtesy of Joel Spivak.)

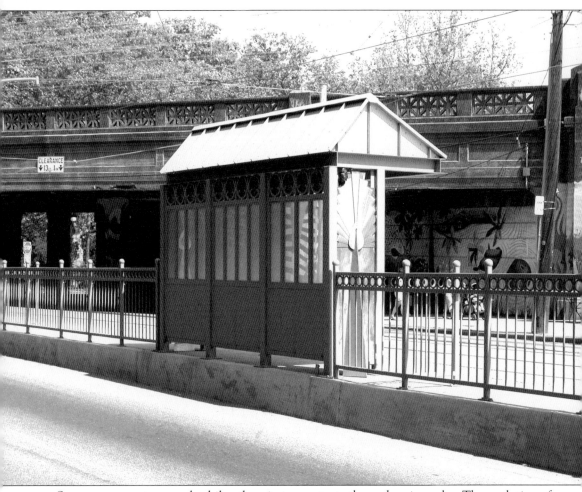

Some eras come to an end, while others just perpetuate themselves in cycles. The evolution of the trolley in Philadelphia is one such cycle. The 1890s ushered in the electrified trolley car, which did not change its basic design until the middle of the second decade of the 20th century. The nearside cars lasted one generation. Then came the modern design of the PCC trolleys across the nation, and Philadelphia proudly ran them across the city. Forty years later, the trolley car survived the test of extinction even though routes were drastically cut in the city and suburbs. The introduction of a new generation of trolleys and trackless trolleys built by a Japanese firm rescued the trolley system from certain death. The high cost of electricity decreased in the 1990s and, when weighed against the detriment of significantly higher gasoline prices and fume emissions from buses, has allowed the trolley to still be with us in Philadelphia. A surprising scene for Allen Meyers and Joel Spivak came in the spring of 2002, when both men witnessed what they had to believe were the construction of new trolley car islands in the middle of Girard Avenue (Thirty-fourth Street at the zoo). Sure enough, the city government, with federal transit grants, plans to revitalize the Route No. 15 trolley. The new shelter awaits the time when the Route No. 15 trolleys will connect West Philadelphia with North Philadelphia again, just as it did more than a century ago.